IMPRESSIONIST MASTERPIECES

IMPRESSIONIST MASTERPIECES

IMPRESSIONIST
MASTERPIECES

NATIONAL GALLERY OF ART, WASHINGTON

BY JOHN HOUSE

INTRODUCTION BY WILLIAM JAMES WILLIAMS

HUGH LAUTER LEVIN ASSOCIATES, INC., NEW YORK

DISTRIBUTED BY

THE SCRIBNER BOOK COMPANIES

ISBN 0-88363-485-6

Printed in Japan

© 1985 Hugh Lauter Levin Associates, Inc., New York

Cassatt paintings © ADAGP, Paris/VAGA, New York, 1985

Bonnard, Monet, and Pissarro paintings © SPADEM,
Paris/VAGA, New York, 1985

CONTENTS

INTRODUCTION 7
ÉDOUARD MANET 24
JAMES McNEILL WHISTLER 34
EUGÈNE BOUDIN 36
CLAUDE MONET 38
PAUL CÉZANNE 50
AUGUSTE RENOIR 62
BERTHE MORISOT 74
EDGAR DEGAS 76
CAMILLE PISSARRO 84
ALFRED SISLEY 90
JAMES TISSOT 92
MARY CASSATT 94
GEORGES SEURAT 98
VINCENT van GOGH 100
PAUL GAUGUIN 106
ÉDOUARD VUILLARD 112
HENRI de TOULOUSE-LAUTREC 116
PIERRE BONNARD 118
TIME LINE 120
INDEX 128

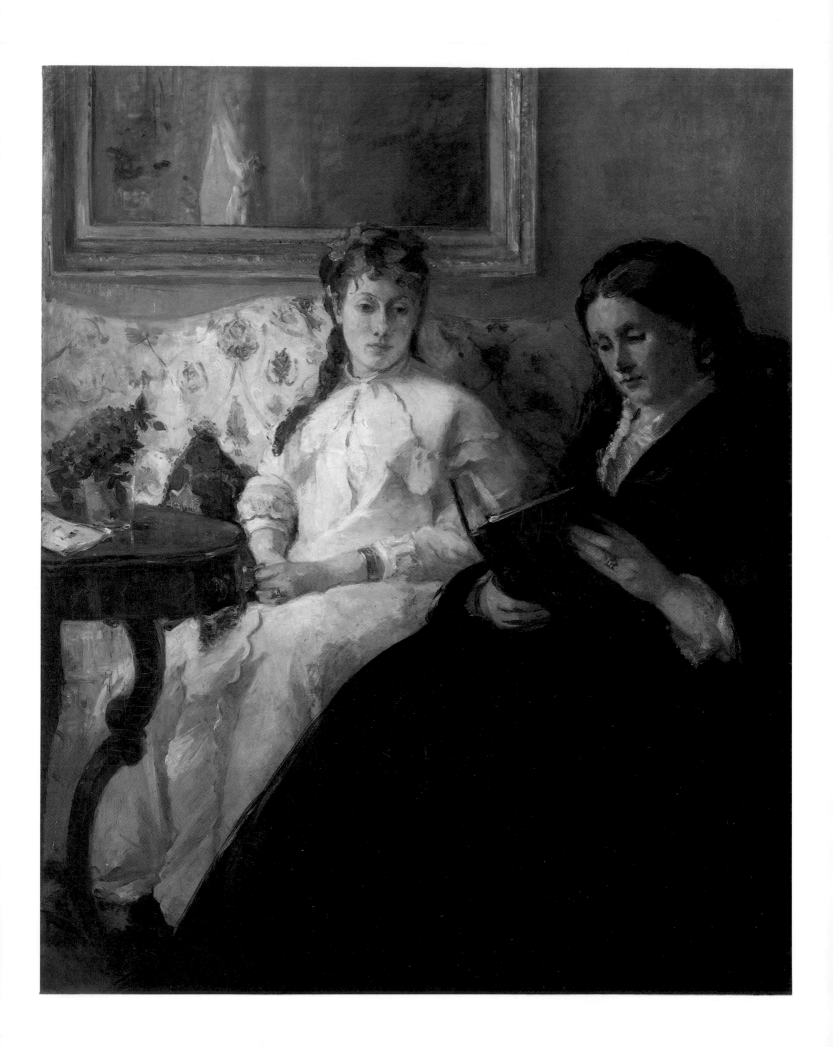

INTRODUCTION

IMPRESSIONISM FROM PARIS TO WASHINGTON

NINETEENTH-CENTURY PARIS

The American and French revolutions of the late 1700s unleashed a furious series of political rebellions that, by changing the nature of Western civilization, also profoundly affected the role of art in a changing society. Painters who had relied on commissions from the court or Church found themselves suddenly without patrons. However, artists who had sold through dealers discovered a vastly increased market, as an affluent upper middle class arose in the emerging republics and democracies.

Unfortunately, these merchants and industrialists usually lacked the cultivated heritage necessary to appreciate the allegorical subject matter and technical virtuosity that had appealed to the aristocrats. Insecure about their education, these newly rich patrons relied on journalist critics and state jurors to establish standards of cultural excellence. The old royal academies of art, reborn as bureaucratic agencies, became the chief arbiters of acceptable taste. Naturally, the more innovative painters rebelled against the rule of this establishment.

In the ensuing tug-of-war between conservative and liberal artistic factions, one of the academies' principal methods of control was to judge the entries in government-sponsored exhibitions of recent art. Such shows in France were called *Salons* after a room in the Louvre Palace where court painters had formerly displayed their creations. Salons became the main forum, indeed almost the only avenue, for presenting artists' works to the press and to potential patrons. Among the hundreds of entries competing for attention at the Salon of 1870 were Berthe Morisot's *Mother and Sister of the Artist* (Figure 1) and Auguste Renoir's *Odalisque* (Figure 2), a harem girl after the exotic fashion of Eugène Delacroix, leader of the romantic painters. Through such exposure, these young artists, who already had participated in previous Salons, received encouragement and advice.

However, if a work violated conventional expectations, it created a sensation. In the 1864 Salon, for example, Édouard Manet's *Incident in a Bullfight* suggested the isola-

Figure 1. (opposite page)
Berthe Morisot
The Mother and Sister of the Artist. *1869–70.*
101 × 81.8 cm
(39½ × 32¼ in.)
Chester Dale Collection, 1963

Figure 2.
Auguste Renoir
Odalisque. *1870.*
69.2 × 122.6 cm
(27¼ × 48¼ in.)
Chester Dale Collection, 1963

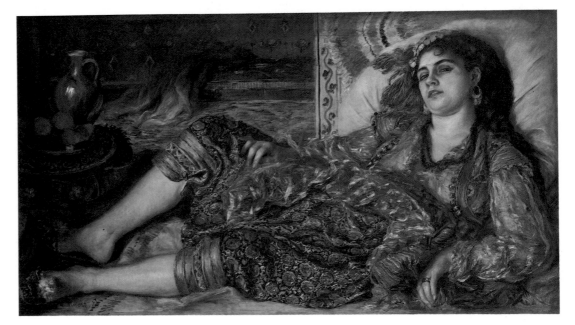

tion of death by juxtaposing a huge foreground bullfighter with a far-distant arena where spectators watched helplessly. This radically bold design aroused scathing derision and newspaper caricatures. Piqued by the criticism, Manet cut the canvas in two. The lower portion is the National Gallery's *Dead Toreador* (Figure 3), while the upper, bullring section is now in the Frick Collection in New York.

Winning a medal at a nineteenth-century Salon ensured professional success. Conversely, the jury's rejection of a submitted entry constituted aesthetic banishment. So many pictures were rejected by the conservative jury at the 1863 Salon that the emperor, Napoleon III, intervened by sponsoring a concurrent exhibit so that the public could compare the officially acceptable pieces with the refused paintings in a

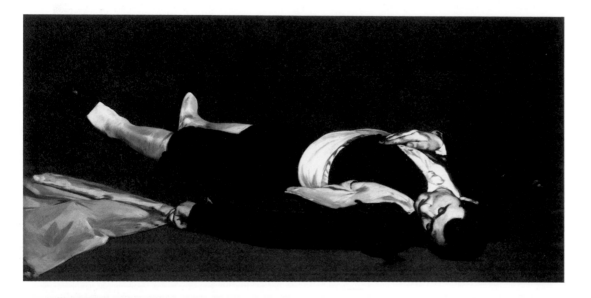

Figure 3.
Édouard Manet
The Dead Toreador. *circa*
1864.
75.9 × 153.3 cm
(29⅞ × 60 ⅜ in.)
Widener Collection, 1942

Figure 4.
Gustave Courbet
The Stream. *1855.*
104.1 × 137.1 cm
(41 × 54 in.)
Gift of Mr. and Mrs. P.
H. B. Frelinghuysen in
memory of her father and
mother, Mr. and Mrs. H.
O. Havemeyer, 1943

Salon des Refusés. This secondary show became an immensely popular venue for jeering and snickering; among its most shocking attractions was James McNeill Whistler's *The White Girl* (Colorplate 6).

To circumvent the academic juries, wealthier artists occasionally mounted independent exhibitions. Gustave Courbet, a realist painter of daily life, for instance, submitted a number of works to the 1855 World's Fair in Paris. The entrance committee accepted his nature paintings, including *The Stream* (Figure 4), but rejected his thematic pictures. Courbet then defied tradition by building his own pavilion outside the fairgrounds. Even though his broad paint handling impressed the elderly Delacroix, few others bothered to attend. Courbet repeated the experiment with greater success in 1867, hanging *The Stream,* along with all his other canvases, separately from the exposition. Manet followed Courbet's lead during the 1867 World's Fair, erecting his own gallery to house a retrospective of his previous paintings, including *The Old Musician* (Colorplate 1), *Still Life with Melon and Peaches* (Colorplate 2), and *A King Charles Spaniel* (Figure 5). These independent performances inspired the idea for a group show by avant-garde painters.

Scientific discoveries paralleled the social upheavals affecting nineteenth-century art. In 1839, for example, Louis Daguerre in Paris and William Henry Fox Talbot in London demonstrated their separate inventions of photographic cameras. Photography soon freed painters and printmakers from the necessity of making mere records of people, places, and events. Photography also introduced a fresh vision into European art. The camera lens inadvertently produced cropped compositions and oblique sight lines, which were studied and replicated by painters in search of novel designs.

In the same year the camera was invented, 1839, a chemist at Gobelins's tapestry studio published the first accurate

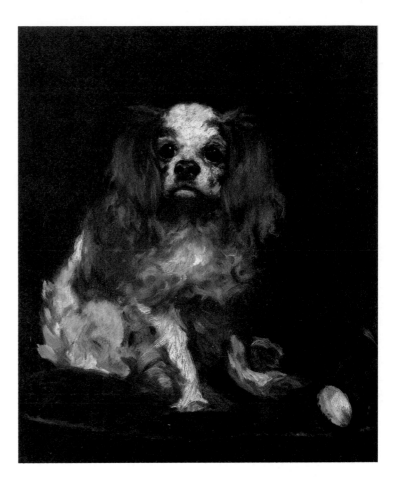

Figure 5.
Édouard Manet
A King Charles Spaniel.
circa 1866.
46.4 × 38.2 cm
(18¼ × 15 in.)
Ailsa Mellon Bruce
Collection, 1970

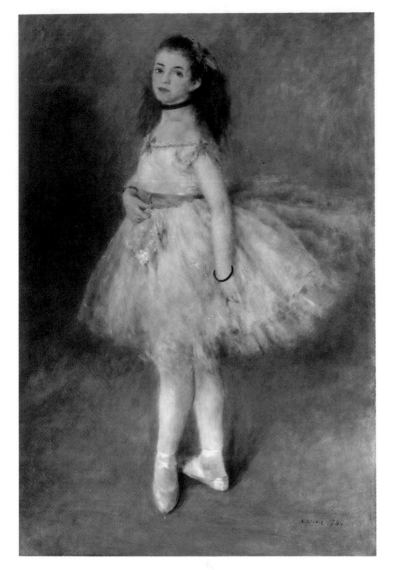

Figure 6.
Auguste Renoir
The Dancer. *1874.*
142.5 × 94.5 cm
(56⅛ × 37⅛ in.)
Widener Collection, 1942

Figure 7. (opposite page, top)
Mary Cassatt
Girl Arranging Her Hair.
1886.
75 × 62.3 cm
(29½ × 24½ in.)
Chester Dale Collection,
1963

Figure 8. (opposite page)
Paul Gauguin
Parau na te Varuaïno
(Words of the Devil).
1892.
91.7 × 68.5 cm
(36⅛ × 27 in.)
Gift of the W. Averell
Harriman Foundation in
memory of Marie N.
Harriman, 1972

explanation of color perception. While developing dyes for textiles, Michel Eugène Chevreul had ascertained that there are three primary hues—red, yellow, and blue—from which all other colors may be mixed. Chevreul's arrangement of hues into a "color wheel" not only elegantly demonstrated a complex scientific idea but also presented artists with a workable theory of pigment mixture. The American physicist Ogden Rood and the German scientist Hermann von Helmholtz made further contributions to the study of optics.

In 1841, the American scientist-artist John Rand patented folding tin tubes to hold spoilable oil paints. Previously, oil painters who wanted to work outdoors had to mix the pigments they thought they might need and then siphon them into glass vials, which break, or animal bladders, which leak. Rand's paint tubes permitted an entire studio to fit into a briefcase and be carried outdoors conveniently. Soon, as one wag quipped, the countryside held more landscapists than farmers.

Eugène Boudin, who was among the more adventurous of these artists, taught his pupil Claude Monet the importance of painting scenes outdoors, "in the light, in the air, just as they are." Painting *en plein air*, Monet quickly introduced his friends Renoir, Sisley, and Bazille to the concept of recording only what is visible at given distances under specific lighting conditions. In the evenings at Parisian cafés, the young artists excitedly, sometimes heatedly, exchanged ideas about their recent discoveries.

On December 27, 1873, these outdoor painting sessions and café discussions culminated in the formation of the *Societé Anonyme des Artistes Peintres, Sculpteurs, Graveurs, etc.* They held their first group exhibition the following spring in the former gallery of Nadar, an experimental photographer. Canvases now in the National Gallery that figured in that epoch-making show include

Renoir's life-sized *The Dancer* (Figure 6) which received critical attacks.

The month-long exhibit that opened on April 15, 1874, included a view by Claude Monet of dawn over a foggy harbor. Its title, *Impression—Sunrise,* prompted Louis Leroy, a conservative art critic, to write a hilariously sarcastic review in which he dubbed the entire group "the impressionists." Although Monet did not object, many others felt that the term was too simplistic; Degas, for example, referred to himself as an *indépendant,* working apart from the Salon establishment. In all, the so-called impressionists gave eight exhibitions irregularly from 1874 to 1886. Although there were fifty-five painters, half entered only a single show. The only artist participating in all eight exhibitions was Pissarro, affectionately nicknamed "Papa" for his even temperament and calming influence.

By the 1880s, however, several of the early impressionists had reacted against purely visual painting. Among the entries at their last show in 1886, for instance, was Mary Cassatt's *Girl Arranging Her Hair* (Figure 7). Upon his first sight of this calculated composition, Degas exclaimed, "What design, what style," and purchased it. Cassatt's variations on purple and repetitions of shapes could not be mistaken for an objective impression of nature. The inspirations behind such changing tastes included Whistler's "art for art's sake" aesthetic theories as well as recent imports from Japan of wood-block prints with strong outlines and dramatic perspectives.

Some painters, such as Georges Seurat and Paul Cézanne, sought to introduce a solid compositional structure into their work. Others, like Vincent van Gogh and Paul Gauguin, ventured into self-expression through stylized designs and color symbolism. Because many of these artists had exhibited in the impressionists' shows but went on to develop other styles afterward, they

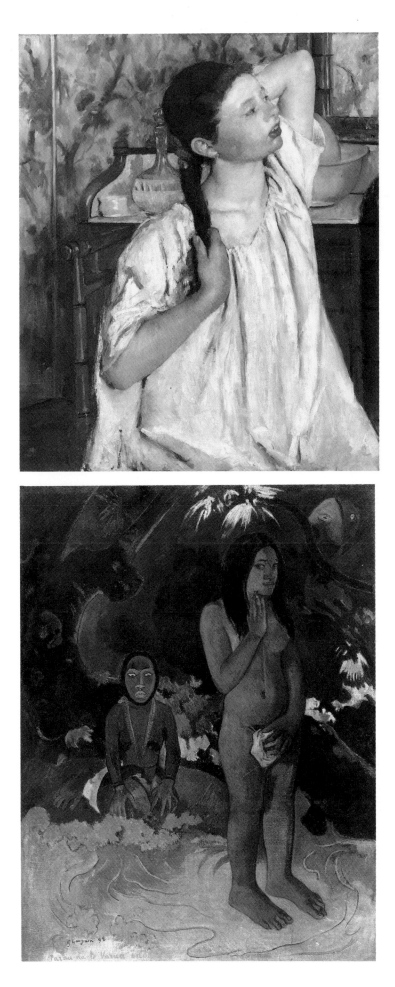

Figure 9.
Edgar Degas
Madame René de Gas.
1872–73.
72.9 × 92 cm
(28¾ × 36¼ in.)
Chester Dale Collection,
1963

Figure 10.
Claude Monet
Morning Haze. *1888.*
74 × 92.9 cm
(29⅛ × 36⅝ in.)
Chester Dale Collection,
1958

were labeled "post-impressionists" by the English critic Roger Fry when he sponsored a modern French exhibition in London in 1910. Most of the post-impressionists were dead and so could not register their reactions to Fry's terminology. Moreover, within three years, Gauguin's *Words of the Devil* (Figure 8) would hang beside canvases by Pablo Picasso, Henri Matisse, and Wassily Kandinsky at New York's controversial "Armory Show" of 1913. Thus, post-impressionism and early twentieth-century art arrived in America simultaneously.

ATLANTIC CROSSINGS

Oddly enough, the first modern French paintings to be seen in the United States were not shipped here from Europe but were created in the New World. Edgar Degas, whose mother was an American Creole, visited his younger brothers, Louisiana cotton merchants, during the winter of 1872–73. While in New Orleans, Degas painted several family portraits. In *Madame René de Gas* (Figure 9), pastel tints and vacant spaces effectively convey the blindness of his sister-in-law Estelle. Degas took this memento back to France, where his first sale to an American patron—the earliest known by an impressionist—was about to take place.

In 1873, even before she met Edgar Degas, Mary Cassatt had persuaded a lady friend to purchase one of his pastel drawings from a Parisian dealer's window. Cassatt's companion soon married H. O. Havemeyer, a New York merchant called "the Sugar King," who became a major donor of French impressionism to American museums. Cassatt's social status as the daughter of a prominent Pennsylvania banker allowed her to exert a subtle influence on her wealthy peers, such as the Havemeyers and Whittemores. Although paramount in her impact on America's late nineteenth-century collectors, Cassatt was

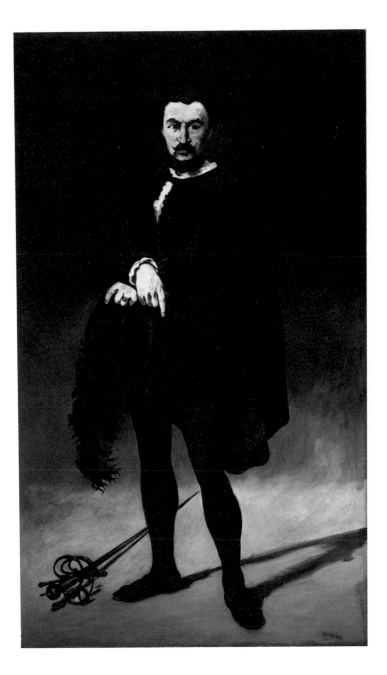

Figure 11.
Édouard Manet
The Tragic Actor.
1865–66.
187.2 × 108.1 cm
(73¾ × 42½ in.)
Gift of Edith Stuyvesant
Gerry, 1959

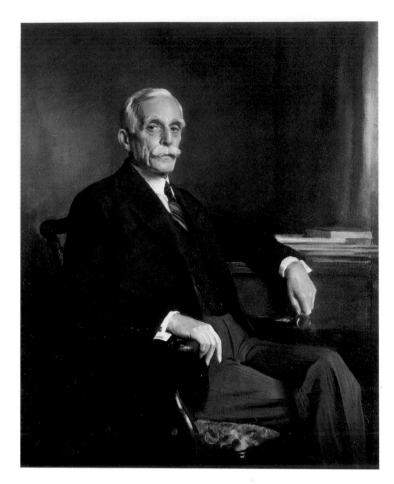

Figure 12.
Oswald Birley
Andrew W. Mellon.
1933.
133.4 × 105.4 cm
(52½ × 41½ in.)
Gift of Mrs. Mellon Bruce,
1941

not alone. Two other famous expatriate painters, James McNeill Whistler and John Singer Sargent, also urged their American contemporaries to buy modern paintings.

Tycoons in the United States are often considered cultural usurpers. To counteract this dubious heritage, they sometimes surround themselves with visible symbols of prestige: costly antiques and rare Old Masters. While partially true, this stereotype ignores the millionaires who embody the brash spirit of their financial success by embracing the equally fresh outlook of modern artists.

The first opportunity to purchase realist and impressionist paintings in the United States came on September 3, 1883, when an industrial trade fair opened at Boston. Its "Foreign Exhibition" of art included Manet's *The Tragic Actor* (Figure 11), a stark portrait of Philibert Rouvière costumed in his celebrated role as Hamlet. Many of these fifty-seven French paintings belonged to Paul Durand-Ruel, a dealer with galleries in Paris and New York. Durand-Ruel later sold this Manet to George Vanderbilt, whose widow gave it to the National Gallery as one of the earliest avant-garde pictures seen on this side of the Atlantic. Durand-Ruel also gave America's second sales exhibition, a huge selection of some three hundred pictures, in New York during April and May of 1886, the exact moment when the last impressionist group show was held in Paris.

The first impressionist to have a one-man show in the United States was Claude Monet, in New York in 1891 and the next year in Boston. *Morning Haze* (Figure 10), a sparkling evocation of dew near Monet's home at Giverny, undoubtedly appeared in one or both of these exhibitions because it belonged to their organizer, a New York art entrepreneur. By 1893, at Chicago's immense World's Columbian Exposition, modern French paintings such as Manet's *Dead Toreador* (Figure 3) clearly dominated the art galleries. This Manet, which three

decades earlier had scandalized Paris, was purchased by Peter A. B. Widener, a Philadelphia railroad magnate with one of the country's most respected collections of Old Masters. Widener's daring demonstration of avant-garde taste set an important precedent for other American patrons. The trickle of French pictures crossing the ocean soon became a flood. Long before the founding of the National Gallery of Art in 1937, innumerable impressionist paintings had been donated to or purchased by museums all over the United States.

TWENTIETH-CENTURY WASHINGTON

A particularly noteworthy Atlantic crossing occurred in 1880, when two young Pittsburgh financiers, Henry Clay Frick and Andrew William Mellon, traveled together on their first European trips; both became avid art collectors. Mellon later retired from business to become Secretary of the Treasury from 1921 until 1932. While ambassador to Great Britain in 1932–33, he sat for one of England's society portraitists, Oswald Birley (Figure 12).

During his career in the District of Columbia, Mellon decided to create a national art gallery; in fact, he purchased many pictures with the specific intention of giving them away, never hanging them in his home. Although rivals for the attention of art dealers, Mellon and Frick remained the closest of friends. Had Frick not died in 1919, he might have joined his collection, now a New York landmark, with Mellon's in forming a museum in Washington.

On March 24, 1937, Congress accepted Mellon's amazing offer of his superb Old Master paintings and statues, an endowment fund, and a building large enough to house the gallery's growing acquisitions for several generations to come. The architect, John Russell Pope, specialized in museums and monuments; the National Archives and the Jefferson Memorial are among his other creations in Washington, D.C. The severe classical edifice he designed for Mellon was, upon completion, the world's largest marble building (Figure 13). Regrettably, neither founder nor architect saw his dream come true; Mellon and Pope both died a few months after the groundbreaking.

The most recent item in Andrew Mellon's collection was a richly colored Venetian scene of the 1840s by Joseph Mallord William Turner, the English romantic landscapist. When asked whether he intended to add impressionism, Mellon answered, "No, I hope others, who know this school better than I do, will contribute such works to the National Gallery." Later, his son and daughter would assemble two of the world's best impressionist collections.

When the National Gallery of Art opened on March 17, 1941, a solitary nineteenth-century French painting had to hold its own against 544 Old Master pictures and fifty Renaissance sculptures. Duncan Phillips, a member of the initial Board of Trustees, gave *Advice to a Young Artist* (Figure 14), by the political caricaturist Honoré Daumier. The subject matter optimistically forecast growth for a new museum, and the canvas bore the distinction of having once been owned by Daumier's close friend and mentor, the lyrical landscapist Jean Baptiste Camille Corot. The generosity of this act was truly boundless because the picture could have been a major component of the donor's own family gallery in Washington, D.C.—the Phillips Collection—founded in 1918 as America's first museum of contemporary art.

Soon, thirty-three modern paintings were lent to accompany this sole Daumier. Borrowed from the Phillips, Dale, and Whittemore families, these nineteenth-century pictures filled a suite of three rooms prominently placed next to the East Sculpture Hall. The Whittemores later gave their two large Whistlers, one of which was his *The*

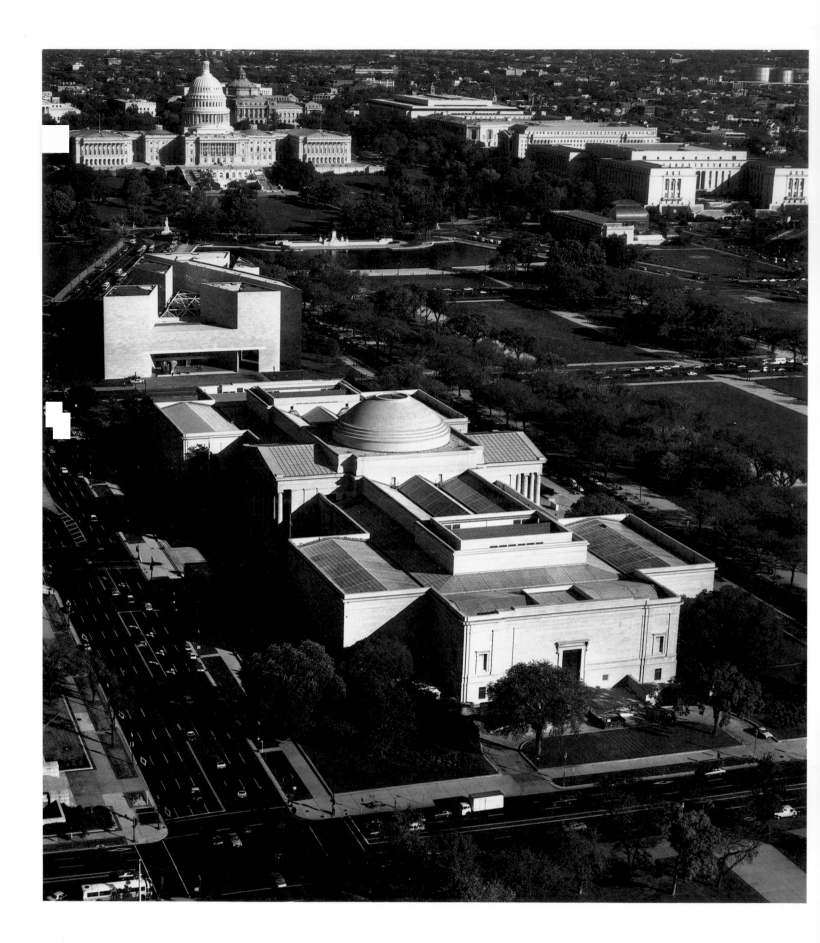

White Girl (Colorplate 6) from the infamous Salon des Refusés.

The modern French paintings in the National Gallery's possession increased tenfold the year after the inauguration of the Gallery. Before he died, Andrew Mellon had an inkling that Joseph Widener might add his treasures to the National Gallery, and this occurred in 1942. Widener donated his Old Master paintings, sculptures, and decorative arts in memory of his father, Peter Widener, who had bought Manet's *Dead Toreador* (Figure 3) early on. Another donation, Degas's *The Races* (Colorplate 28), reflects the family's passion for thoroughbreds. The Wideners' progressive tastes showed in Renoir's *The Dancer* (Figure 6) from the first impressionist show. Thus, although the National Gallery's impressionist holdings were initially small, they already contained works of historic importance.

In 1943, the Gallery acquired its first Courbet, *The Stream* (Figure 4). Its donor, Mrs. Frelinghuysen, gave the canvas in honor of her mother, Mrs. Havemeyer, the first American patron known to have bought an impressionist picture. Similarly, Mrs. Frelinghuysen's brother, Horace Havemeyer, presented Manet's *Gare Saint-Lazare* (Colorplate 3) in their mother's memory. From 1958 to 1960, Agnes and Eugene Meyer, publisher of *The Washington Post,* gave Manet's *Still Life with Melon and Peaches* (Colorplate 2) and, to add Cézanne's work to the Gallery, four of his canvases, such as *Le Château Noir* and *The Sailor* (Colorplates 18 and 19).

During the Gallery's first two decades, twenty donors built up a collection of forty-five French paintings from the latter half of the 1800s. Listing these early benefactors reads like a *Who's Who* of publicly spirited American families. The impressionist works on view, however, greatly exceeded those that the Gallery owned. Since the fall of 1941, for example, Manet's monumental *The Old Musician* (Colorplate 1) and Renoir's

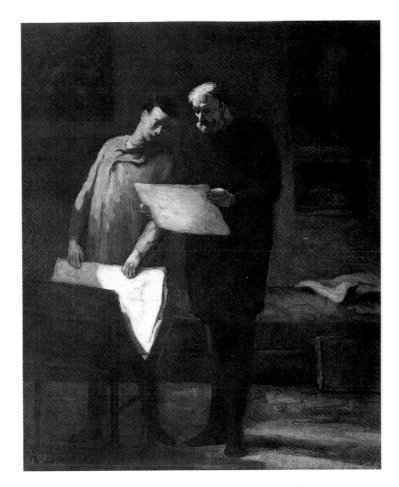

Figure 13. (opposite page) The National Gallery of Art, looking eastward toward Capitol Hill: West Building, designed by John Russell Pope, built 1937–41; East Building, designed by Ieoh Ming Pei, built 1971–78. Photograph by William J. Sumits

Figure 14. Honoré Daumier Advice to a Young Artist. circa 1860. 41 × 33 cm (16⅛ × 12⅞ in.) Gift of Duncan Phillips, 1941

Figure 15.
George Bellows
Chester Dale. *1922.*
113.7 × 88.3 cm
(44¾ × 34¾ in.)
Gift of Chester Dale, 1945

perennially popular *A Girl with a Watering Can* (Colorplate 22) had been hanging on loan from Chester Dale. As he lent more and more pictures, new display spaces were added beside the initial three rooms for modern art. In 1958, Dale gave the Gallery its first Claude Monet, *Morning Haze* (Figure 10). But as Dale also lent and donated to other museums, no one knew the ultimate destination of his collection.

Chester Dale was a self-made millionaire. He began as a Wall Street messenger boy and quickly emerged as a major investor. His interest in art began after he married Maud Dale, an amateur painter who had studied in Paris. Dale's acumen at art collecting soon matched his sharpness in the stock market. Shrewdly, he bought a partnership in the Galerie Georges Petit, a major Parisian dealership. Thereby an art agent himself, Dale not only knew beforehand which masterpieces might be coming up for sale but also eliminated dealers' percentage fees. Maud and Chester Dale commissioned works from contemporary painters, too, such as his refreshingly candid portrait in golfing attire by George Bellows (Figure 15).

Dale's death in 1962 revealed the National Gallery of Art to be the recipient of his entire collection. Eighty-eight paintings from his Manhattan apartment joined the 152 pictures already on loan. Virtually every major impressionist and post-impressionist was represented by prime examples, as were current Parisian painters such as Picasso and Matisse. With such a broad survey in such a concentrated field, the Dale bequest formed a foundation upon which all future additions of late nineteenth- and early twentieth-century art will rest. For instance, before Berthe Morisot sent her shimmering *The Mother and Sister of the Artist* (Figure 1) to the 1870 Salon, her future brother-in-law, Édouard Manet, repainted the mother. Berthe's sister, Edma, also posed for her *The Harbor at Lorient* (Colorplate 26), which was presented to the Gallery years later by an-

other donor. Thus, by artist and by theme, the complementary holdings have increased ever more quickly.

In 1966, the Gallery celebrated its twenty-fifth anniversary with a special exhibition drawn exclusively from the collections of founder's two children. "French Paintings from the Collections of Mr. and Mrs. Paul Mellon and Mrs. Mellon Bruce" displayed 247 pictures from the mid-nineteenth to the early twentieth centuries. A promise of things to come, nearly half these loans subsequently passed to the Gallery. The generosity of so many donors exceeded the wildest predictions, and the Gallery outgrew its original facilities for display and scholarship far more rapidly than anticipated. Paul Mellon and Ailsa Mellon Bruce then agreed to finance an expansion program, which was later assisted by the Andrew W. Mellon Foundation. Ailsa Mellon Bruce, like her father, passed away without seeing the project fulfilled; in fact, she died two years before groundbreaking in 1971. Her brother, Paul Mellon, supervised every aspect of design and construction. The new East Building, of marble matching the original, now called the West Building, opened on June 1, 1978. The architect, Ieoh Ming Pei, like his predecessor John Russell Pope, specializes in public buildings. Pei brilliantly conquered the problem of a trapezoidal site by erecting a dramatic polygonal structure (see Figure 13).

Ailsa Mellon Bruce had acted as her father's hostess when he was ambassador to Great Britain. She later served the National Gallery as an anonymous benefactor, supplying funds for such masterpieces as the only Leonardo da Vinci painting outside of Europe. Her personal taste accounts for the 1955 purchase of Captain Edward Molyneux's collection, which had been seen three years earlier in a Gallery loan show. A

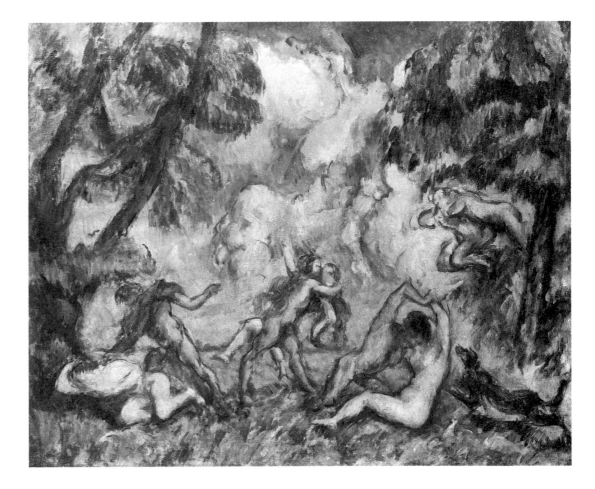

Figure 16.
Paul Cézanne
The Battle of Love. *circa 1880.*
37.8 × 46.2 cm
(14⅞ × 18¼ in.)
Gift of the W. Averell Harriman Foundation in memory of Marie N. Harriman, 1972

British couturier with a Parisian dress salon, Molyneux devoted his connoisseurship to acquiring intimate impressionist canvases, including Berthe Morisot's *The Harbor at Lorient* (Colorplate 26), Vincent van Gogh's *Farmhouse in Provence, Arles* (Colorplate 39), Pierre Bonnard's *Two Dogs in a Deserted Street* (Colorplate 48), and Édouard Vuillard's *Child Wearing a Red Scarf* (Colorplate 45).

A few Molyneux paintings, such as Monet's *Bazille and Camille* (Colorplate 8), were not petite. Shortly after Mrs. Bruce's death in 1969, they were hung alongside the larger works she had acquired individually, such as Renoir's *Pont Neuf, Paris* (Colorplate 21). Most Molyneux pictures, however, were too tiny to compete with the West Building's vast rooms. Thus, for a decade after Mrs. Bruce's bequest, the Gallery stored these charming works. Installed for the East Building's inauguration in 1978, "Small French Paintings" instantly became a public favorite.

Space limitations prevented the display of other French pictures, too. In 1972, Averell Harriman, former governor of New York and ambassador to the Soviet Union, gave twenty-three paintings in memory of his late wife. She had established her own New York business, the Marie Harriman Gallery, in 1930 and had directed this modern art dealership until 1942. Marie Harriman acquired many of the pictures in her husband's memorial of her, twelve of which are realist or post-impressionist. Cézanne's *The Battle of Love* (Figure 16), a vividly powerful interpretation of a classical theme, had once belonged to Renoir. *Words of the Devil* (Figure 8) illustrates the temptation of the "ancient Eve," which Gauguin mentioned in a letter to the Swedish author August Strindberg. This Tahitian Eden also demonstrates Gauguin's fascination with particular motifs in that the tree in the forest is the same one seen on the beach in his *By the Sea*.

Recent additions continue to augment the collection. John Hay Whitney, publisher of the New York *Herald Tribune* and, like Andrew Mellon, an ambassador to Great Britain, passed away in 1982. Following his wishes, his widow has distributed some of

their nineteenth- and twentieth-century paintings among the National Gallery of Art, New York's Museum of Modern Art, and New Haven's Yale University Art Gallery. Mrs. Betsey Whitney's careful selections will benefit all three institutions by filling in their respective gaps or amplifying their extant strengths. *Coast near Antibes* (Figure 17), for instance, is the Gallery's first work by the post-impressionist Henri Edmond Cross. In his Riviera landscape, Cross exaggerated Seurat's luminous points of light into a stylized pattern of emphatic dots. *Wapping on Thames* (Figure 18), on the contrary, reinforces a distinguished group of Whistlers. Begun *en plein air* at Wapping, a London port, this is one of Whistler's few scenes done outdoors, although he later repainted

Figure 17. (opposite page)
Henri Edmond Cross
Coast near Antibes.
1891–92.
65.1 × 92.3 cm
(25⅝ × 36⅜ in.)
John Hay Whitney
Collection, 1982

Figure 18.
James McNeill Whistler
Wapping on Thames.
1860–64.
72.3 × 102.2 cm
(28½ × 40¼ in.)
John Hay Whitney
Collection, 1982

Figure 19.
Frédéric Bazille
Negro Girl with Peonies.
1870.
60.2 × 75.5 cm
(23¾ × 29¾ in.)
Collection of Mr. and Mrs.
Paul Mellon, 1983

it in his studio. In the meantime, the female model Joanna Hiffernan had become his mistress and posed for *The White Girl* (Colorplate 6).

Paul Mellon, the founder's son and successor on the Board of Trustees, supports the National Gallery and several other educational institutions. With the modesty characteristic of this family, Paul Mellon has allowed no fanfare to trumpet his donations. Pictures on long-term loan would be transferred to the Gallery bit by bit. Although Cézanne's *The Artist's Father* (Colorplate 14) did receive a public announcement, few other such occasions have

prompted press releases. An astute visitor could spot these additions only by noticing that paintings which on the previous day had been identified by labels on the wall had acquired, overnight, plaques on their frames.

On January 28, 1983, however, Mr. and Mrs. Paul Mellon made so significant a gift that the Gallery did announce the acquisition of ninety-three works, including twenty-six canvases by the impressionists and post-impressionists. Among the rarest is Frédéric Bazille's *Negro Girl with Peonies* (Figure 19), finished just months before the twenty-eight-year-old painter was killed in action in the Franco-Prussian War. Because Bazille left only sixty pictures, it is not surprising that the Gallery possessed only one other work by him. A formative figure in the rise of impressionism, he was Claude Monet's best friend when portrayed in the latter's *Bazille and Camille* (Colorplate 8).

Starting with one canvas by Honoré Daumier at its inauguration in 1941, the National Gallery of Art now has a breathtaking sweep of nearly three hundred realist, impressionist, and post-impressionist pictures. As of this writing, nine new galleries in the West Building are being converted from former office and storage areas. Fully one-quarter of the main floor will display nineteenth-century French paintings. Because Andrew Mellon wisely had insisted that public taxes never be expended on acquisitions, the Gallery's phenomenally rapid rise as a world-class museum of Old Master and modern art must be credited to the benevolence of over five hundred philanthropists.

William James Williams

Figure 20.
Room view showing, left to right, Manet's Still Life with Melon and Peaches *(Colorplate 2), Cézanne's* The Artist's Father *(Colorplate 14), Manet's* Ball at the Opera *(Colorplate 4), Monet's* Bazille and Camille *(Colorplate 8), and Manet's* Gare Saint-Lazare *(Colorplate 3).*

THE OLD MUSICIAN
ÉDOUARD MANET (1832 – 1883)

*T*he Old Musician was Manet's largest canvas to date, but he did not submit it to the official Salon in Paris. It was exhibited in a Paris gallery early in 1863, and Manet sent to the 1863 Salon the still larger *Déjeuner sur l'herbe* (Jeu de Paume, Paris), which was painted soon afterward. It was the *Déjeuner,* rejected by the Salon jury and shown at an exhibition of the rejected pictures, that made Manet notorious, with its combination of clothed men and a naked woman at a picnic. Yet *The Old Musician,* too, was a bold statement of Manet's artistic position, of his ambition to paint monumental subjects from contemporary life.

Its compositional arrangement obeys none of the traditional academic rules for creating a unified, focused composition placed in a defined space. Instead, the figures are loosely strung across the picture, with their surroundings scarcely indicated. Their relationship to each other seems almost haphazard, and the seated musician, ignoring his companions and gazing out of the picture at the viewer, further disrupts the coherence of the group. The picture's theme—a collection of poor itinerants—was rare in contemporary French painting and unknown on this huge scale, a scale more appropriate, it was felt, for the depiction of a great historical event than for a group of outcasts. The apparent casualness of the composition well expresses the aimlessness and lack of purpose of the figures. Manet's choice of subject and its arrangement represent deliberate gestures against the artificiality of contemporary historical painting. At the same time, the picture includes many references to the Old Masters, notably to great painters of everyday life such as Velásquez and the Le Nain brothers; Manet used these references to support his ambition to paint lowly modern types in a monumental exhibition painting.

The painting's subdued colors complement its theme. The fall of light and shade is not treated with naturalistic precision; instead, the zones of light and dark are used to make the figures stand out clearly and boldly. The brushwork, too, is never precise in the rendering of details but is used with great fluency to sketch in the forms of the figures. Arrangement and handling alike give the painting a great immediacy and presence.

Colorplate 1.
The Old Musician.
1862.
187.4 × 248.3 cm
(73¾ × 97¾ in.)
Chester Dale Collection,
1962

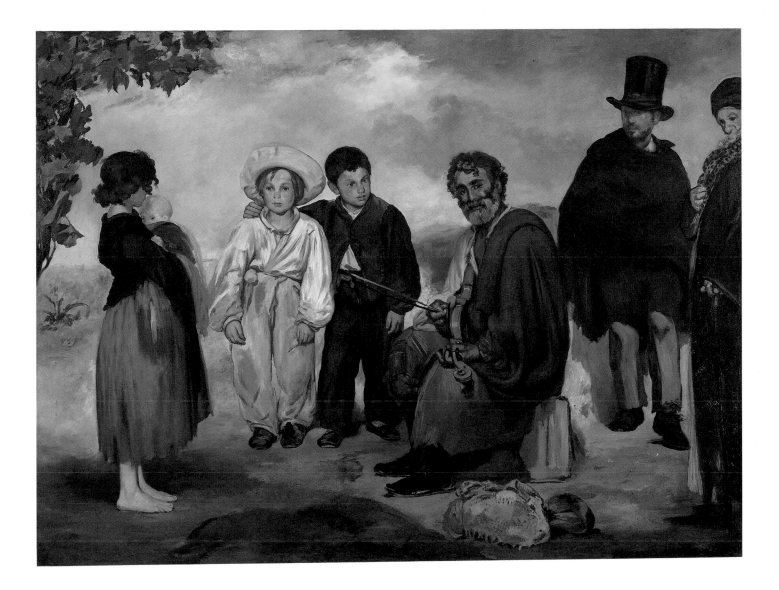

STILL LIFE WITH MELON AND PEACHES
ÉDOUARD MANET

Manet treated the objects in his still lifes as he treated the human figure, in bold visible touches of paint emphasizing the arrangement of forms and colors across the canvas but making no attempt to describe details of surface or texture. Viewed from close by, the brushwork gives no sense of the wrinkled surface of the melon, but from a distance its effect is richly suggested. Nor was Manet concerned to place his objects in a completely coherent space. The folds of the tablecloth on the left of the picture are puzzling; a flat area of dull gray appears where the viewer expects to find a suggestion of the forms and modeling of the cloth.

Oddities such as this appear in many of Manet's paintings. He consistently sought to emphasize the fact that his paintings were not direct imitations of nature but belonged necessarily within their rectangular, two-dimensional format; their forms and rhythms had to be organized in relation to this flat pictorial surface. In this context, the gray area at the bottom left of the still life—so curious in naturalistic terms—plays an essential part in the picture, anchoring the light area of the tablecloth within the frame and giving it a weight to counterbalance the rich dark browns of the table at bottom right. It is through these rhymes and contrasts of color and texture in the paint that the picture evokes its subject.

Just as Manet had paid tribute to past painters of everyday life in figure paintings such as *The Old Musician* (Colorplate 1), here his arrangement of fruit, bottle, and glass shows his allegiance to the French eighteenth-century painter Chardin, who had similarly transformed groupings of everyday objects into grand pictorial compositions.

Colorplate 2.
Still Life with Melon
and Peaches.
circa 1866.
69.0 × 92.2 cm
(27⅛ × 36¼ in.)
Gift of Eugene and
Agnes Meyer, 1960

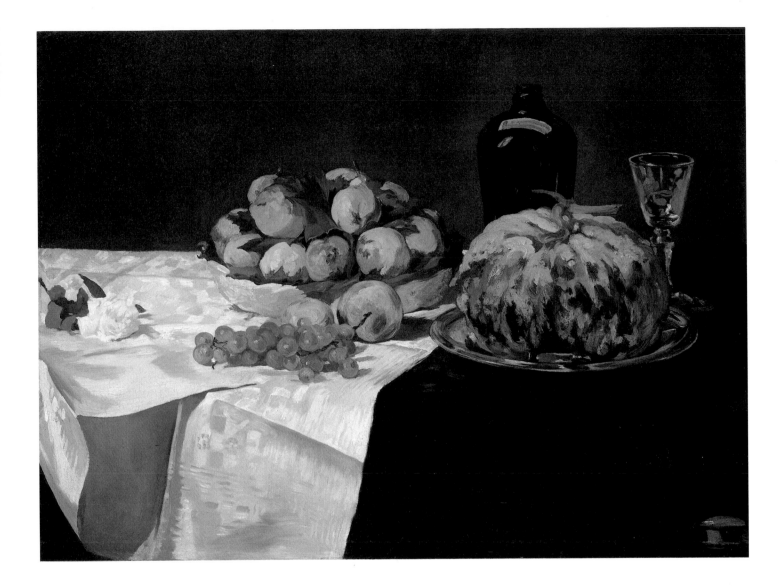

GARE SAINT-LAZARE
ÉDOUARD MANET

Gare Saint-Lazare was exhibited at the Paris Salon in 1874 with the title *The Railroad*. The previous year, Manet had won considerable success at the Salon with *Le Bon Bock* (Philadelphia Museum of Art), a comparatively conventional image of an old man with a glass of beer. The fact that he submitted *Gare Saint-Lazare* to the Salon in 1874, together with *Ball at the Opera* (Colorplate 4), which was rejected, shows that he made no attempt to cash in on his success, for they are two of his most challenging paintings.

The painting is set in a garden overlooking the tracks leading out of one of Paris's main railroad stations, the Gare Saint-Lazare; the cloud of smoke shows that a train has just passed. But the real subject of the picture is the two figures in front of the railings. They are together, yet there is no obvious relationship between them, and many contrasts are set up between their figures: one seated, one standing; one in a light dress with hair up, one in dark with her hair down; one looking at us, one turned away. The gaze of the seated figure adds to the uncertainty, because she invites us, as spectators, into the picture without hinting at our relationship to what we see.

Images of women with girls were common in contemporary French painting, but they showed the woman in a parental role: tending, protecting, or teaching the child. Manet's picture, with its undefined relationship, constitutes a rejection of these artificial conventions, presenting the figures as if caught unaware, yet their contrasting poses are locked together with great care in the canvas by means of rhymes and contrasts of color, line, and texture. The ambiguity of the subject is increased by the fact that the train, which the original title *The Railroad* evoked, is absent; the girl stares out only into the white emptiness of the patch of smoke.

It was by means of these deliberate uncertainties and unanswered questions that Manet aimed to give his paintings a real sense of the fleeting, fragmented life of the modern city, which this picture captures so forcibly.

Colorplate 3.
Gare Saint-Lazare.
1873.
93.3 × 114.5 cm
(36¾ × 45⅛ in.)
Gift of Horace Havemeyer in memory of his mother, Louisine W. Havemeyer, 1956

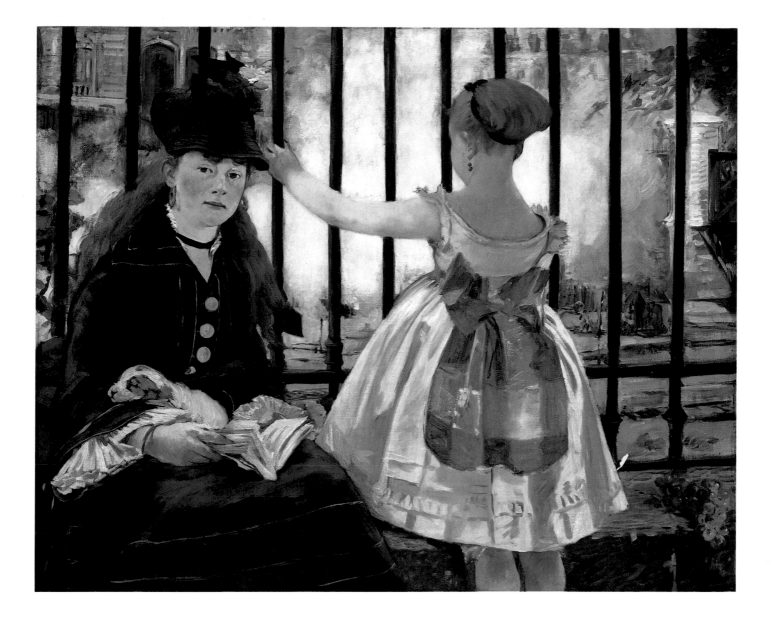

BALL AT THE OPERA
ÉDOUARD MANET

Of the two oil paintings Manet submitted to the Paris Salon in 1874, *Gare Saint-Lazare* (Colorplate 3) was accepted, but *Ball at the Opera* was rejected. This is not surprising, perhaps, because the latter painting has a more risqué subject and a more unconventional composition than any other canvas Manet sent to the Salon.

Masked balls were held on Saturday evenings in the winter in the foyer of the old Opera building in Paris. Manet began to paint this subject in spring 1873, but the building burned down that October; by the time he sent it for exhibition in the spring of 1874, the social rituals shown in the picture were past history.

At the time, masked balls were widely seen as sanctioning sexual immorality; only the women wore masks, allowing them to meet their lovers with apparent anonymity. Manet's picture shows many moments of sexual exchange. Amid the sea of black top hats, the masked faces of the women—and one that is unmasked—are the focus of male attention. Some of the women feign modesty; some respond eagerly. The composition emphasizes the sense of busy informality through the apparently random cutting off of the figures at its margins and by its lack of a single focus; viewers are left to imagine such interchanges going on all around us.

Amid all this activity, Manet introduces details hinting at a wider significance for the painting. The legs of the girls in tights on the balcony, harshly cut by the picture's frame, seem to project a physical female presence over the scene below; at the left, a figure in the costume of Polichinelle from the *commedia dell'arte* (an archetypal image of the clown) enters the scene with an apparent gesture of alarm; and at bottom right, the painter's signature appears on a discarded visiting card on the floor with, above it, a self-portrait looking out at the spectator from the back of the crowd. These elements seem to establish his—and the spectator's—role as observer and commentator, viewer or voyeur, of the pictorial world presented in this densely packed composition. But the artist is both inside and outside the picture, and the spectators, are given no grounds upon which to pass judgment on what they see.

Colorplate 4.
Ball at the Opera.
1873.
59.0 × 72.5 cm
(23¼ × 28½ in.)
Gift of Mrs. Horace Havemeyer in memory of her mother-in-law, Louisine W. Havemeyer, 1982

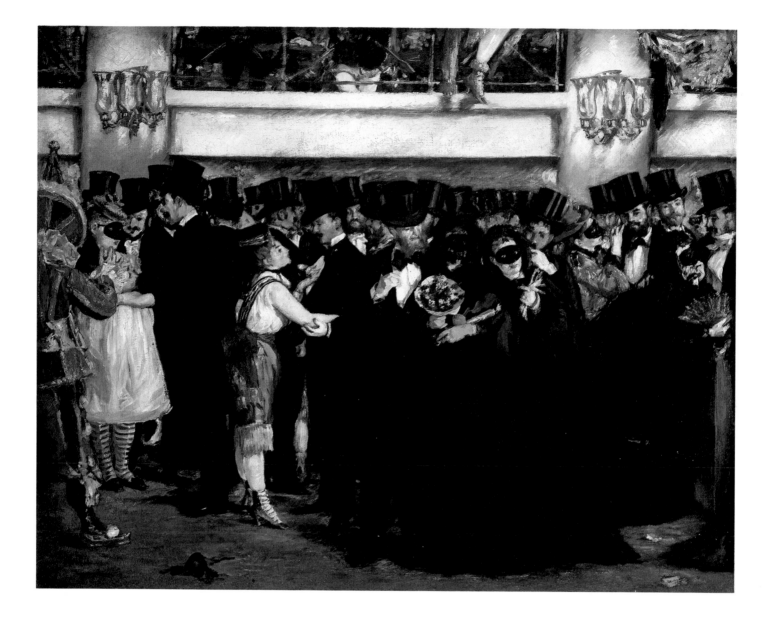

THE PLUM
ÉDOUARD MANET

*T*he *Plum* is at first sight a straightforward depiction of a girl in a café, with a plum in brandy, then a common drink. Manet has added a few signs that help suggest what type of girl she is. Her head resting, perhaps too heavily, on her hand and her distant expression suggest that she may already have been drinking, and her cigarette shows that she is a lower-class girl or a prostitute, because only those classes smoked in public. But even these clues do not help define our relationship to her: Are we seated at her table? Is she aware of our presence? Is she alone or in company? Where, if anywhere, is her attention focused? The painting poses but deliberately refuses to answer questions such as these.

By portraying his model like this, Manet has presented a set of questions that must have recurred often in Paris café life at the time, where the possible availability of a girl was a constant focus of male attention. The painting translates these questions into a permanent pictorial form: the simple pyramidal shape of the girl, inclined a little to the left; the delicate harmony of her pink dress and the dull crimson seat, placed against the soft green screen behind her head; and the fluent, apparently casual brushwork that artfully evokes the immediacy of a chance encounter. Manet repeatedly reworked his paintings until they satisfied him completely, but the final appearance of a painting like *The Plum* wholly belies the endless pains he took to achieve so apparently spontaneous an effect.

Colorplate 5.
The Plum.
circa 1877.
73.6 × 50.2 cm
(29 × 19¾ in.)
Collection of Mr. and
Mrs. Paul Mellon, 1971

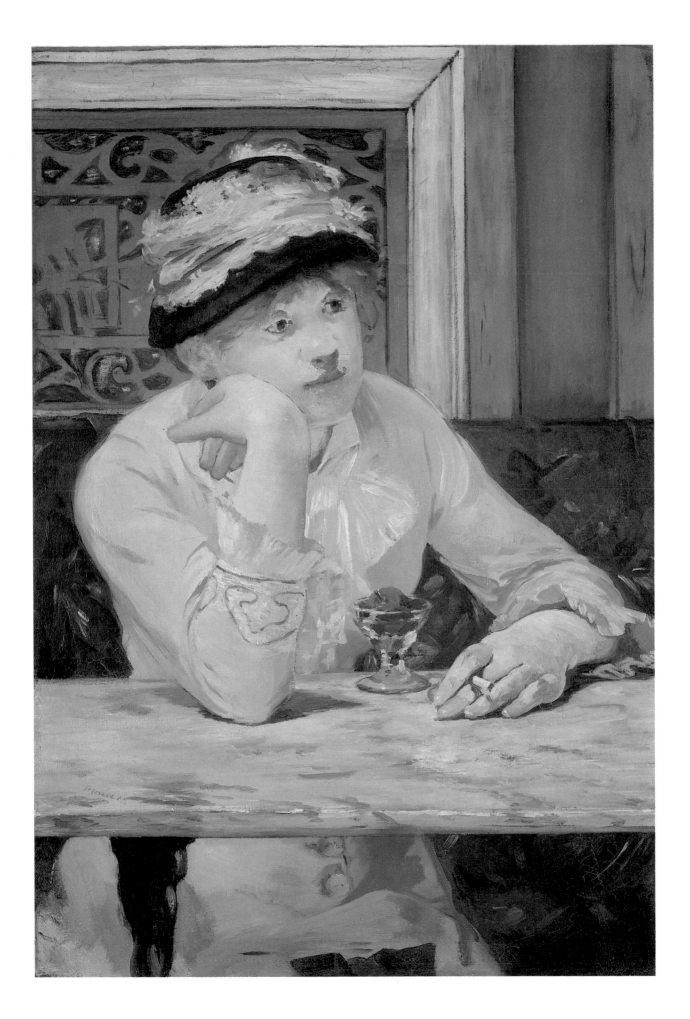

THE WHITE GIRL
JAMES McNEILL WHISTLER (1834–1903)

Although Whistler was American by birth and *The White Girl* was first exhibited in London in 1862, he received his principal artistic training in Paris. *The White Girl* won its greatest notoriety in Paris when it was exhibited in the showing of the canvases rejected by the jury of the 1863 Salon.

At this date, Whistler, like Manet, was looking at the great Old Master painters of contemporary life (see Colorplate 1). His main forerunner was Velásquez, in the freely brushed paint surfaces and in the painting's elongated format, which is similar to the Spanish master's full-length court portraits. But *The White Girl* is not just a tribute to the past; it dealt with issues that were central to painting in the early 1860s, particularly the question of pictorial narrative. When it was exhibited, critics read stories into it; the model was interpreted as a girl the morning after her wedding night, and the picture was associated with Wilkie Collins's celebrated recent novel, *The Woman in White.*

At the time, Whistler insisted that the painting "simply represents a girl dressed in white, standing in front of a white curtain," but he must have realized that his audience would make such interpretations. The girl's expression and the flowers in her hand and on the floor, together with the animated head of the bearskin, invite some sort of reading. Whistler may have included these details to provoke the critics so that he could give himself a chance to rebut them by insisting that a painting was, first and foremost, a painting and not a story. In another picture of the same period in the National Gallery of Art, *Wapping on Thames* (Figure 18), he originally, in 1861, intended a theme of explicit sexual confrontation; but before exhibiting the picture in 1864 he replaced this theme with the present grouping of figures, with no apparent story. Within a few years after *The White Girl,* he had wholeheartedly espoused the cause of "aesthetic" painting, whose justification lay in the pictorial qualities of the work of art alone; it was at this point that he retitled the picture *Symphony in White No. 1.*

The White Girl is a key painting of its time, at a crossroads of Victorian British narrative painting, Parisian painting of modern life, and the painting of the emerging "aesthetic" movement.

Colorplate 6.
The White Girl. *1862.*
214.7 × 108 cm
(84½ × 42½ in.)
Harris Whittemore
Collection, 1943

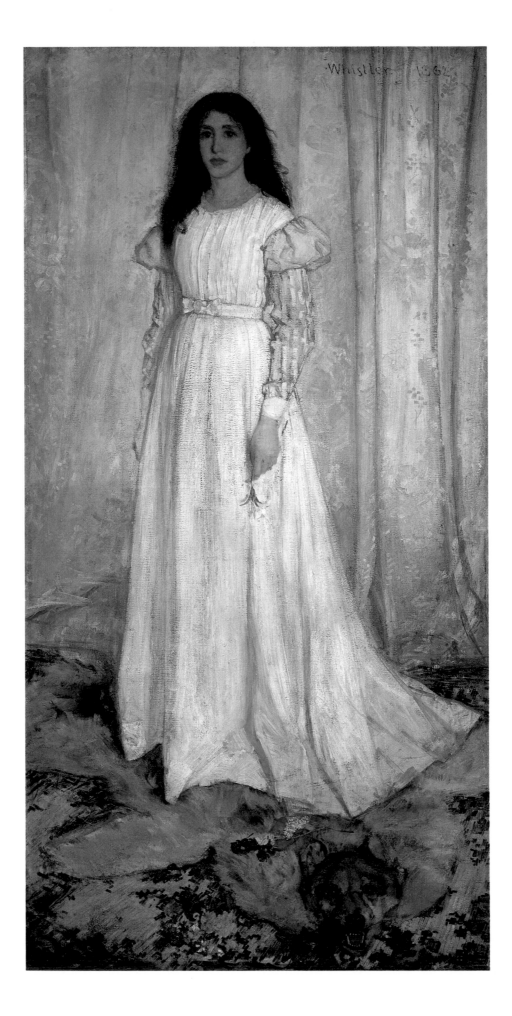

JETTY AND WHARF AT TROUVILLE
EUGÈNE BOUDIN (1825–1898)

This is among the finest of the pictures of the Normandy seacoast for which Boudin is famous. The building of railway lines had brought the Normandy coast within easy reach of Paris from the 1840s onward and seaside villages, such as Trouville and Deauville, quickly became fashionable summer resorts. From the early 1860s, Boudin made his reputation with pictures of this tourist population. Initially, the modernity of the subject was still controversial; the seacoast had traditionally appeared in painting as the setting for the local fisherfolk or to convey the elemental conflict between waves and shore. Boudin wrote in 1868 to justify his choice of subjects: "The peasants have their painters, but surely the bourgeois who walk on the jetty towards the sunset also have the right to be fixed on canvas." These ideas were very close to those expressed by Charles Baudelaire in the essay "The Painter of Modern Life," in which he advocated the pageantry of modern life as a suitable subject for painting; Boudin had met Baudelaire while he was working out the ideas for this essay. In these years, too, Boudin often worked with Monet, who was painting similarly contemporary subjects (see Colorplate 8).

The theme of *Jetty and Wharf at Trouville* is modern, with the band of black smoke signaling the presence of the steamboat beside the jetty. But the composition does not revolve around this focus in a traditional way; instead, the boat is largely hidden by the crowded figures. The lamp standard—equal in weight to the ship's funnel and masts—creates an alternative focus in the center, and the sailboat on the left introduces a further theme (recreational sailing was popular at this time). Nor does the attention of the crowd focus on a single point; the child with a white skirt is pointing toward them, but the other figures look in many directions, and the dogs ignore human activity. It was through the deliberate informality of his composition that Boudin expressed the flavor of modern life.

The painting is executed with great delicacy but without its details being allowed to distract from the overall effect. Boudin based paintings like this on studies made outdoors, but its comparative precision suggests that he may have executed the final canvas in the studio.

Colorplate 7.
Jetty and Wharf at
Trouville. 1863.
34.6 × 57.8 cm
(13⅝ × 22¾ in.)
Collection of Mr. and
Mrs. Paul Mellon, 1983

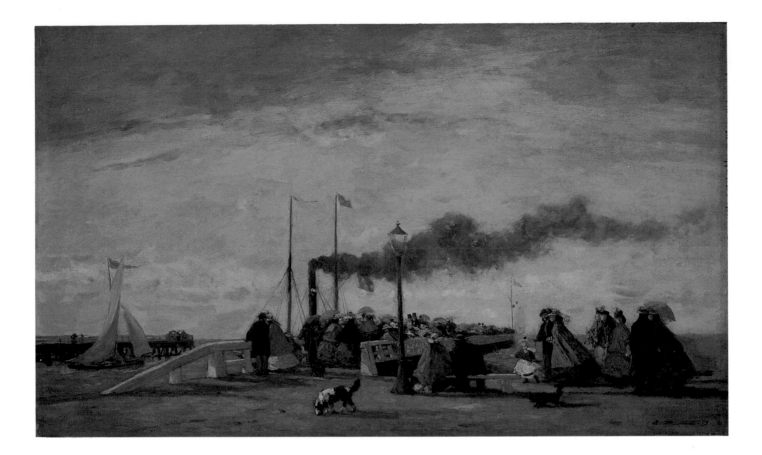

BAZILLE AND CAMILLE
CLAUDE MONET (1840–1926)

In the summer of 1865, Monet embarked on an ambitious attempt to make his reputation with a vast picnic scene located in the Fontainebleau forest, painted as an attempt to outdo Manet's notorious *Déjeuner sur l'herbe* (Jeu de Paume, Paris) of 1863. In place of Manet's elaborately contrived composition and the shock value of the nude woman in that picture, Monet designed a deliberately informal grouping of many people in a woodland glade with the sunlight filtering through the trees. His final canvas was never completed, and only fragments of it survive (one is in the Jeu de Paume, Paris). *Bazille and Camille* is one of two studies for it which Monet completed as independent pictures. The other (Pushkin Museum, Moscow) shows the whole composition, while here only the two left-hand figures are seen; however, each one is treated as a composition which is complete in itself, not as a fragment of the larger whole.

Monet presumably painted *Bazille and Camille* while staying at Chailly in the Fontainebleau forest in the summer of 1865; the huge final picture was executed later, in the studio. Monet's painter friend Bazille, who posed for the man here and for several of the other male figures in the large composition, visited him at Chailly only late in the summer; the female figure, with others in the composition, was posed by Camille Doncieux, whom Monet was later to marry (see Colorplate 10).

From the spectator's viewpoint, the two figures are largely in shade, with a few crisp strokes capturing the sunlight as it catches their shoulders and Bazille's hat. This lighting focuses our attention on the broad shapes of the figures as they are silhouetted against the greenery, on the characteristic contours of fashionable modern dress. Their faces, in deep shadow, are treated very simply; Monet has focused on the general effect of the figures as types rather than on details of physiognomy or expression. The play of light and shade across the foliage and ground is suggested in a rapid shorthand of strokes, vigorously brushed across the surface. The simple, sketchlike technique gives the picture a great sense of immediacy.

Colorplate 8.
Bazille and Camille.
1865.
93 × 69 cm
(36⅝ × 27⅛ in.)
Ailsa Mellon Bruce
Collection, 1970

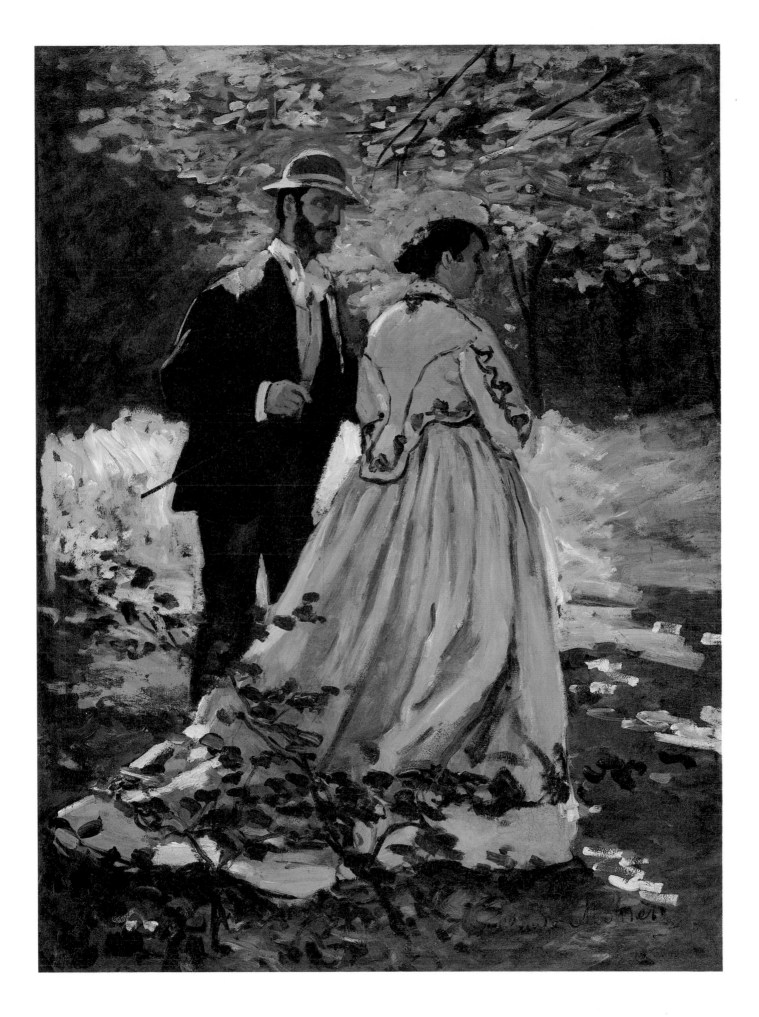

ARGENTEUIL
CLAUDE MONET

Monet lived at Argenteuil, a town on the Seine a few miles northwest of Paris, from 1872 until 1877. The town was becoming industrialized and was also one of the main centers for recreational sailing in the Paris region. Particularly in his first paintings of the place, such as *Argenteuil,* Monet emphasized its diversity. In *Argenteuil,* the varied elements in the scene are all treated with equal strokes of paint: the trees in the distance and the sailboats, the factory chimneys and the house, the tree trunks on the right and the figures beside them, and the streaks of sunlight across the foreground path. Like Degas in *The Races* (Colorplate 28), painted at around the same date, Monet seems intent on emphasizing that no one aspect of the view in front of him is more important than the others; all were integral to the character of a scene whose very diversity summed up the varied facets of suburbanization in the surroundings of Paris.

During the 1870s, Monet was trying to execute his landscapes outdoors in a search to capture the play of natural light, but often changing weather and lighting must have thwarted him. It seems unlikely that so carefully painted a scene as *Argenteuil* was executed entirely outdoors; the background is treated with great finesse, and the boldest brushstrokes visible are not a part of a rapid initial sketch of a natural effect but rather the dashes of color added late in the execution of the painting across the foreground to suggest the fall of sunlight on the path. The darker greens of the trees on the right frame the scene and help lead the eye into it, but alongside this the colors are light and varied in order to convey the effect of light and atmosphere, with a soft play of opposed warm and cool tones set off against the many nuances of green in the foliage and grass.

Nowhere in the picture was Monet waylaid by distracting detail, but the comparatively careful handling and restrained color suggest that this was one of the paintings that Monet intended for sale through the commercial dealer market, in contrast to the more sketchy, improvisational canvases, such as *Woman with a Parasol—Madame Monet and Her Son* (Colorplate 10), which he generally sold only to friends.

*Colorplate 9.
Argenteuil.
circa 1872.
50.4 × 65.2 cm
(19⅞ × 25⅝ in.)
Ailsa Mellon Bruce
Collection, 1970*

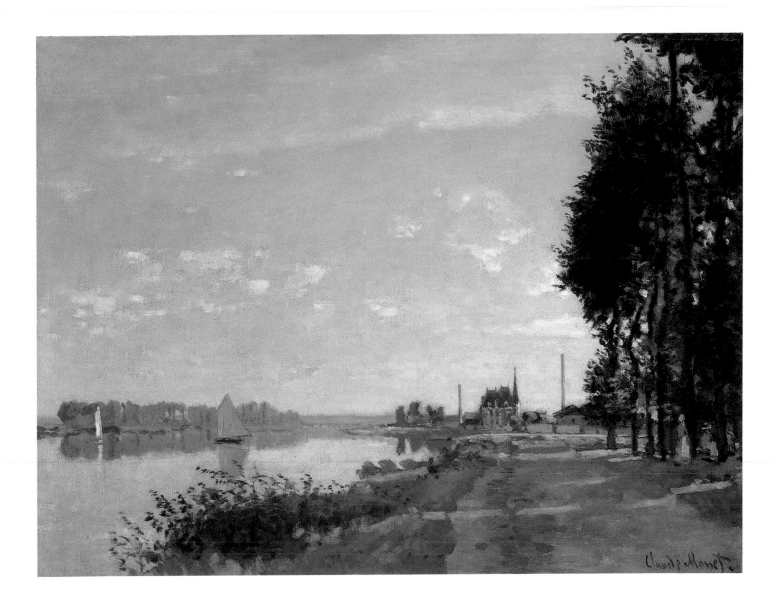

WOMAN WITH A PARASOL—MADAME MONET AND HER SON
CLAUDE MONET

This was a canvas for which Monet had a particular liking; over ten years later, memories of it encouraged him to paint two further canvases of girls with parasols (Jeu de Paume, Paris). By adopting a remarkably low viewpoint—around the level of his wife Camille's feet—Monet gives the scene an air of the unexpected, of the suddenly perceived effect, while their eight-year-old son Jean seems just to have appeared over the brow of the hill. The painting's technique enhances this sense of immediacy; in contrast to *Argenteuil* (Colorplate 9) or *Banks of the Seine, Vétheuil* (Colorplate 12), it is vigorously and rapidly sketched, not elaborately finished for sale to a dealer. The freedom of its handling suggests that it was painted in the open air; the absence of the finer and more measured brushwork seen in the more finished paintings strongly suggests that it was not subsequently refined by reworking in the studio.

Although the broad sweeps of paint in the sky are very different from the crisp, individual dashes of color in the grass and the supple, flowing strokes on the woman's dress, all combine to evoke a breezy summer day. Parts of the sky are particularly lightly worked, with areas of the light-toned, putty-colored canvas priming left virtually unpainted. The sunlit areas in the grass are conveyed by varied light and rich greens, while in the shadows cast across the foreground there are deep greens and some soft dull blues along with a succession of dull red-brown strokes. By this time, Monet did not use a uniform color to express shadow or sunlight but suggested the interplay of light and shade by setting varied darker, duller hues against the lighter, brighter accents. As in *Bazille and Camille* (Colorplate 8), the figures are lit from behind, but here the rippling strokes that show the sunlight striking the edges of their figures are far more vivacious than in the earlier painting, and even the shaded parts of Camille's dress are treated with such varied colors that we cannot be sure whether the actual color of its material is white or light blue. This is an archetype of impressionist open-air painting in the way the whole scene is absorbed into a play of animated colored touches.

Colorplate 10.
Woman with Parasol—
Madame Monet and
Her Son. *1875.*
100 × 81 cm
(39⅜ × 31⅞ in.)
Collection of Mr. and
Mrs. Paul Mellon, 1983

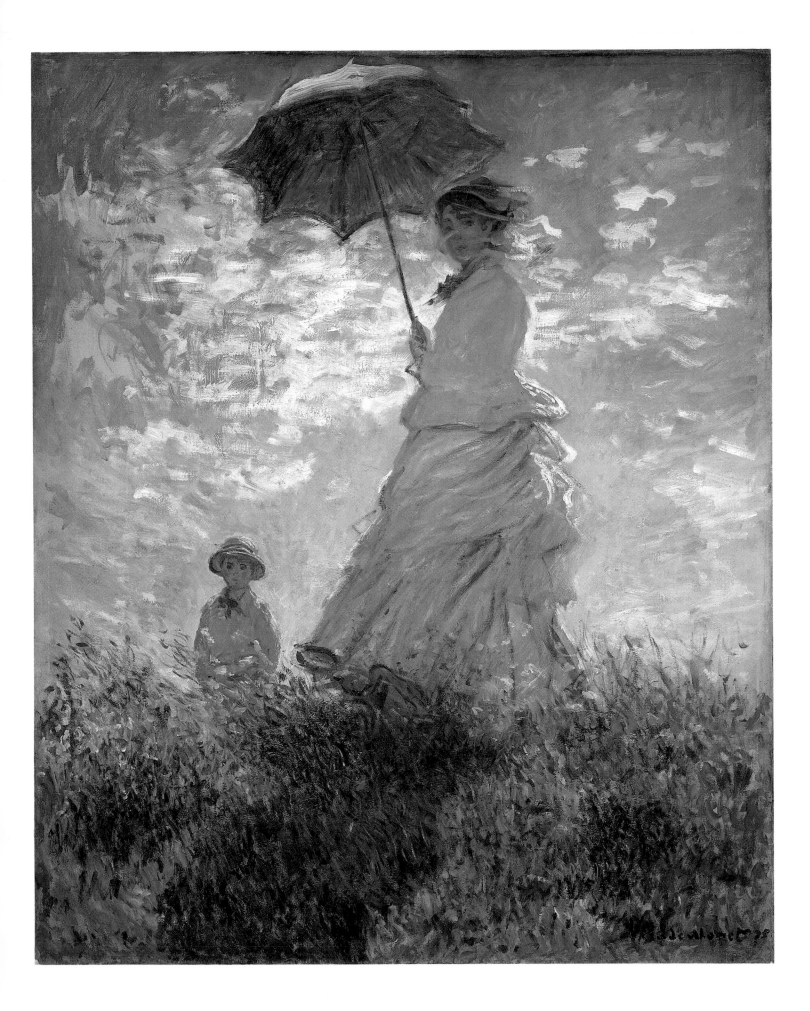

WOMAN SEATED UNDER THE WILLOWS
CLAUDE MONET

Woman Seated under the Willows is one of the most ebulliently painted works of Monet's career. The grass and foliage, in the fresh light of a spring day, are evoked by vigorous hooks and dashes of color, while the stems of the young willows are treated by long streaks of paint that are very free in their movement but extraordinarily controlled in their execution. The foreground figure is handled much like the rest and is almost absorbed into all this activity.

For all the apparent spontaneity, the results Monet achieved were carefully worked out. In several parts of the canvas, particularly in the trees on the left, he allowed the primed canvas, a light brown in color, to remain unpainted and to play an important part in the final effect. This priming is unusually dark for Monet, who generally painted on canvases primed in light tones or white; its underlying warm midtone is set off against the greens and blues that dominate the painting. Varied greens suggest the lit foliage and grass, and blues run throughout the picture, in the sky and the foliage, in the distant houses, and in the shadows that play across the figure and the foreground grass. The care with which Monet gauged the final color effects can be seen in the long stems of the willows. Their color is endlessly varied, sometimes light blue, sometimes green, at times a dull mauve, a brown, or a very dark blue or green. At each point, the color was chosen so as best to allow their lines to stand out in the picture while harmonizing with what lies around them.

The dynamic sketching technique here is very different from the handling in Monet's most elaborately finished paintings of this period, such as *Banks of the Seine, Vétheuil* (Colorplate 12). There the touches are smaller and the marks more subtly interwoven, in contrast to the air of immediacy and freshness that the brushwork in *Woman Seated under the Willows* evokes so strongly.

The painting was executed on an island in the Seine at Vétheuil (see Colorplate 12), with the hamlet of Lavacourt seen through the trees.

Colorplate 11.
Woman Seated under the Willows. *1880.*
81.1 × 60 cm
(31⅛ × 23⅝ in.)
Chester Dale Collection,
1962

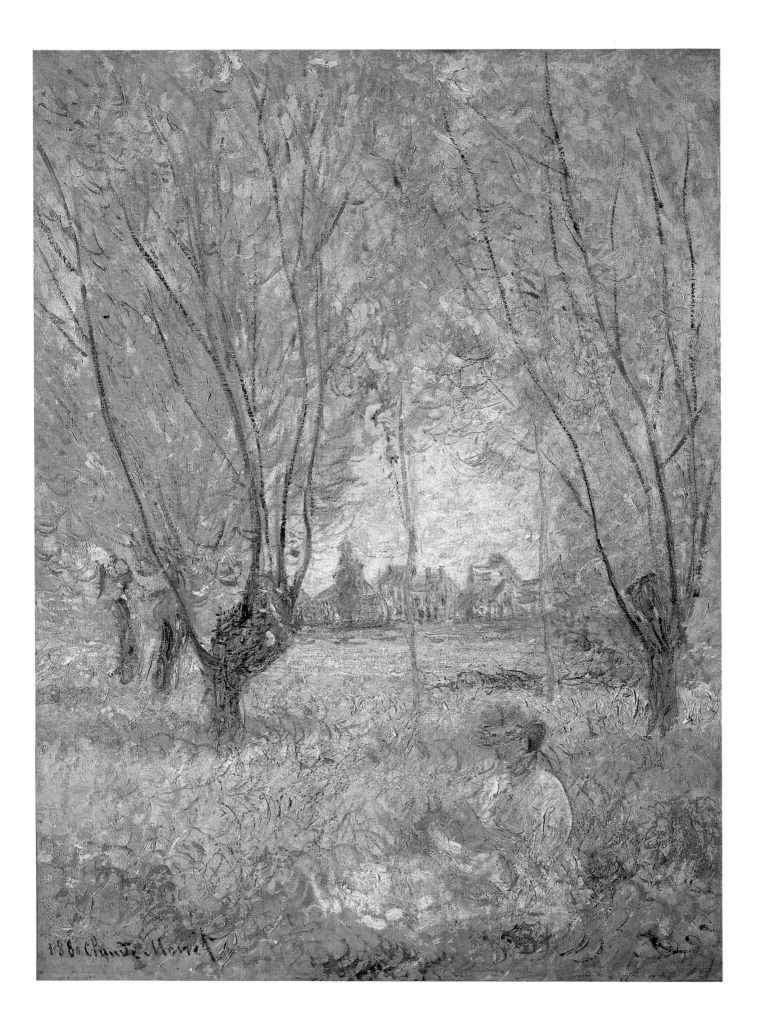

BANKS OF THE SEINE, VÉTHEUIL
CLAUDE MONET

In 1878, Monet went to live at Vétheuil, a small village on a remote loop of the Seine downstream from Paris, a place unaffected by industrialization or tourism. He ceased to paint subjects with the overtly modern ingredients that had fascinated him at Argenteuil (see Colorplate 9) in favor of images of the seemingly timeless village or, as here, nature largely unaffected by the human presence. Only a very few of these scenes, such as *Woman Seated under the Willows* (Colorplate 11), contain figures; from 1880 onward, he focused with increasing single-mindedness on effects of light and atmosphere in his landscapes (see Colorplate 13).

Around 1880, Monet began increasingly to elaborate the surfaces of his most highly finished paintings, such as *Banks of the Seine, Vétheuil;* it was with paintings of this sort that he began to find a regular market in the 1880s, particularly through the dealer Durand-Ruel. He was seeking to characterize more fully the textures of nature, but at the same time his use of brushwork and color in such paintings gave greater emphasis to the two-dimensional organization of the surface of the picture.

The variety of the brushwork here does suggest the variety of nature's textures, but the brush weaves complex alternating sequences of verticals and horizontals as the eye moves up the canvas from the stems of the plants to their flowers, across the ripples and reflections on the water to the trees and clouds. The range of color is restricted, virtually all within the range of green-yellow through green to blue, but within this narrow compass endless variations of hue and tone are introduced to describe the plants and foliage and to suggest the passage from foreground to atmospheric distance. Only the painting's clear red signature stands out against the dominantly green-blue color scheme. The subtlety and complexity of the brushwork and color transform a subject without obviously picturesque features into a richly satisfying painting.

Colorplate 12.
Banks of the Seine,
Vétheuil. 1880.
73.4 × 100.5 cm
(28⅞ × 39⅝ in.)
Chester Dale Collection,
1962

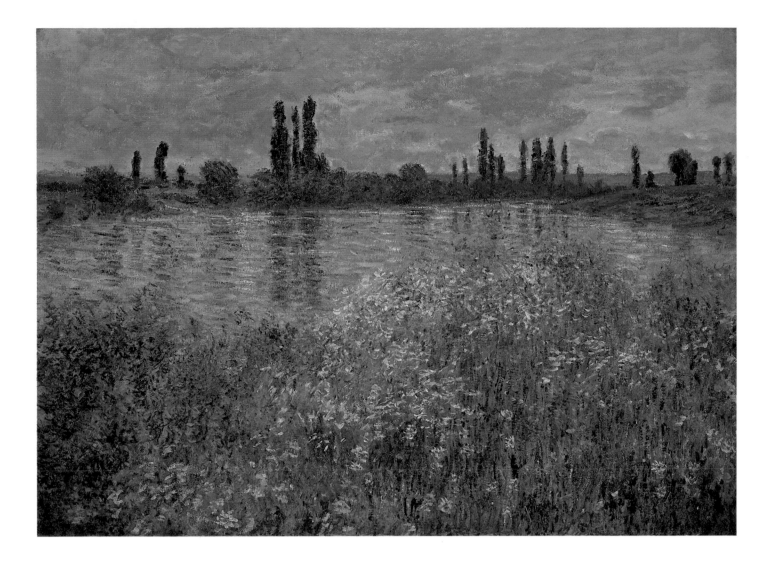

ROUEN CATHEDRAL, WEST FACADE
CLAUDE MONET

In his later works, Monet became increasingly preoccupied with finishing his paintings, developing the concern with the pictorial surface that appeared in *Banks of the Seine, Vétheuil* (Colorplate 12). But whereas there his main concern was with natural textures, by the 1890s he had become preoccupied with rendering fleeting effects of atmosphere; he began to work in long series of paintings of a single subject whose variations of color would evoke the effects of changing light. The starting point of these pictures was a short-lived light effect, but their final effect was the result of protracted reworking and elaboration that often involved long periods of work in the studio, far away in time and place from the initial natural effect.

Monet began his paintings of Rouen Cathedral during spells at Rouen early in 1892 and 1893 and continued to work at them at home in his studio; they were exhibited in the spring of 1895. They are the most thickly reworked of all Monet's series; indeed, contemporary critics likened their paint surfaces to the surfaces of the stone facade of the cathedral itself. But this does not seem to have been Monet's intention; the density of the paint was the result of the length of time he took to complete these paintings.

Rouen Cathedral, West Facade shows the cathedral in the morning, with the sun catching only the south-facing surfaces. Almost all of the facade is in shadow, but it is full of color, treated primarily in sequences of blues, mauves, and oranges that wholly veil the largely colorless stone of the building. Stronger blues model some of the main forms of the facade and suggest some of the deepest shadows, like that in the rose window; in the shadowed portals below, warmer mauves and oranges play a major part, too.

This complex color scheme goes far beyond any directly observed natural effect; the picture is treated as a colored harmony evoking the play of light and shade. The other painting from this series (in the National Gallery of Art) showing the facade in afternoon sun, is dominated by whites and yellows, but it too uses duller mauve, orange, and blue to suggest the forms of the building. The two pictures together show how Monet gave interrelated harmonies to different canvases within a single series.

Colorplate 13.
Rouen Cathedral,
West Facade. 1894.
100.4 × 66 cm
(39½ × 26 in.)
Chester Dale Collection,
1962

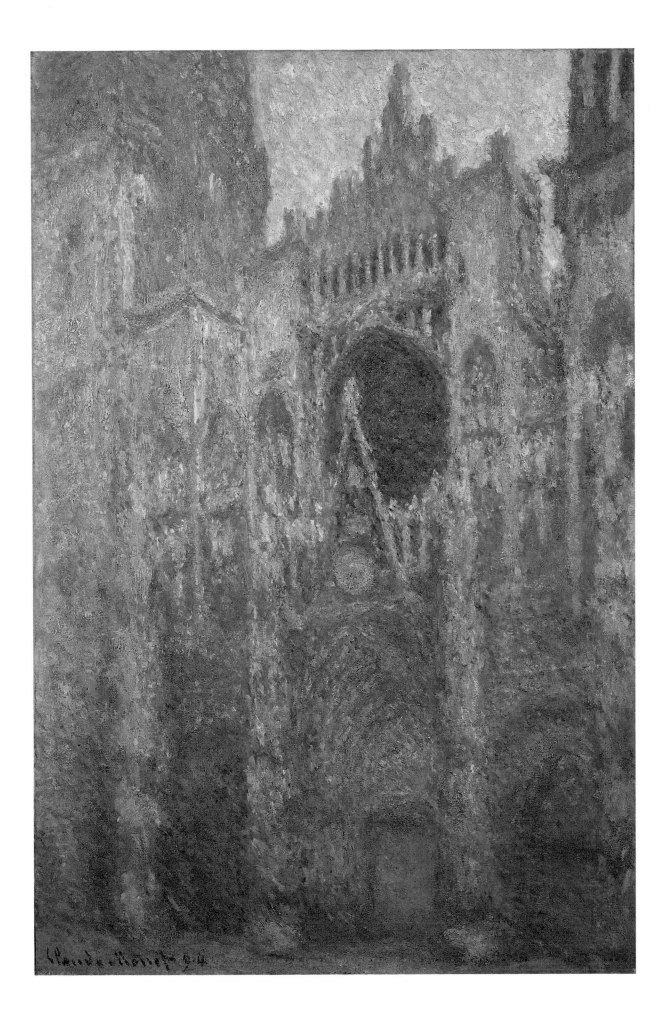

THE ARTIST'S FATHER
PAUL CÉZANNE (1839–1906)

As a gesture against conventional ideas about finish in painting, which favored smooth, almost invisible handling, many young artists in the 1860s adopted the technique, favored by Gustave Courbet, of applying paint with the palette knife (see also Renoir's *Diana,* Colorplate 20). Cézanne, in paintings such as *The Artist's Father,* used the knife more boldly, laying on color in great swathes sometimes an inch or more wide and creating very thick paint layers that are sometimes disconcertingly flat in their effect. This boldness—even crudeness—of attack in Cézanne's technique was a deliberate strategy; when interviewed in 1870 about his painting, which had become notorious although it had never been accepted for exhibition at the Salon, he replied: "I paint as I see, as I feel—and I have very strong sensations. . . . I dare, Sir, I dare. . . I have the courage of my opinions."

The Artist's Father is one of his largest and most ambitious paintings from this period. His father had made a substantial fortune as a banker in Aix-en-Provence in southern France and had little patience with his son's artistic ambitions. He is shown informally dressed, seated beneath a still life by Cézanne, and reading the newspaper *L'Evénement.* It was in this paper that Cézanne's boyhood friend Émile Zola published a controversial review of the Salon in 1866, the year Cézanne painted this portrait. Zola reprinted his reviews the same year with a formal dedication to Cézanne. Therefore, Cézanne showed his father surrounded by the signs of his and his friend's artistic ambitions.

The color is mostly very restricted, but hotter reds are introduced at some points in the flesh, with the blue vase and green fruit in the still life on the wall supplying stronger color accents near the top of the picture. The modeling of the figure is suggested partly by the broad slabs of paint but also by the harsh black outlines surrounding much of it, boldly setting it apart from the background. This is a bold exaggeration of the simplified modeling Manet had used in *Olympia* (Jeu de Paume, Paris), which had aroused so much criticism at the Salon the previous year.

Colorplate 14.
The Artist's Father.
1866.
198.5 × 119.3 cm
(78⅛ × 47 in.)
Collection of Mr. and
Mrs. Paul Mellon, 1970

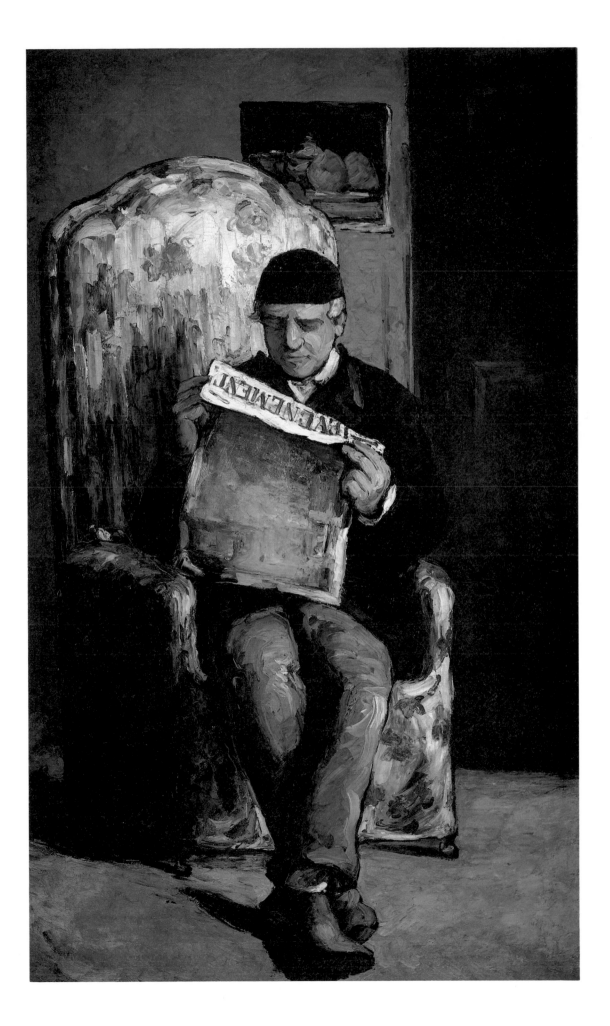

HOUSE OF PÈRE LACROIX
PAUL CÉZANNE

From 1872 to 1874, Cézanne lived at Auvers, north of Paris, in order to work with Camille Pissarro and learn to paint from the close observation of nature, wishing to curb the impulsive, imaginative treatment of his earlier paintings. At this time, Pissarro was painting with varied, economical touches of color, which evoked the variety of nature's forms and textures (see Colorplate 31). *House of Père Lacroix* shows Cézanne's attempts to apply similar methods.

But the painting is in no way an imitation of Pissarro's manner. In the foliage, the distinct strokes of the brush are larger and more insistent, and the walls and roof of the house are treated with a greater solidity of paint than Pissarro was using at the time. The canvas shows a succession of objects receding into space, one beyond the other, but the very solid paintwork makes the viewer aware of the flatness of the picture's surface. Indeed, the space above the roof at the left is very ambiguous: Are we seeing a hillside or further buildings below the little flat square of blue sky in the corner of the painting? Cézanne often chose landscape subjects of this type, where he faced the subject frontally, with the forms from foreground to background stepped up the canvas (see Colorplate 16), in contrast to the more traditional type of landscape view in which the viewer's eye passes into space through a perspectival recession into the center of the picture (see Colorplate 9).

Cézanne signed few of his paintings and dated still fewer. The signature and date on *House of Père Lacroix* may suggest that he was particularly pleased with the painting, and it is possible that this was one of the canvases he showed in the first independent exhibition organized by the impressionist group in Paris in the spring of 1874. Because, unlike the other impressionist landscapists, he had regular support from his wealthy family, he did not need to finish and sign as many paintings as possible for prospective sale.

Colorplate 15.
House of Père
Lacroix. *1873.*
61.3 × 50.6 cm
(24⅛ × 20 in.)
Chester Dale Collection,
1962

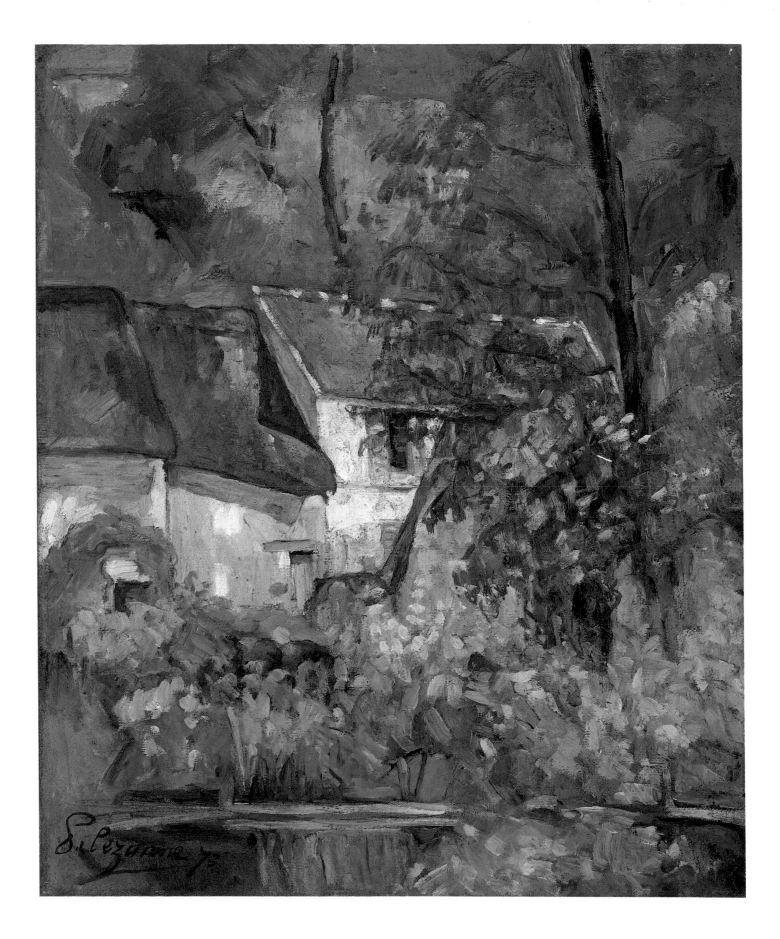

HOUSES IN PROVENCE
PAUL CÉZANNE

From about 1875 on, Cézanne began to seek a greater overall coherence in his handling of paint, in reaction to the more varied textures he had sought while working with Pissarro in the early 1870s. Paintings such as *Houses in Provence,* of around 1880, mark the extreme point of this self-imposed discipline. Large parts of the surface are covered with diagonal strokes of paint, all running virtually parallel, which give the picture a strong dominant rhythm. The few areas not so treated—notably the sky and the houses—are more smoothly handled, with only soft variations of touch. The crisp effect of the painting is intensified by the simplified drawing of the forms in it; bands of rocks are treated as simple strips or arcs, and buildings are reduced to geometrical solids. The edge of the shadow that the left house casts on the wall to its right is particularly sharply demarcated and adds an incisive contrast exactly halfway across the canvas.

The few areas where the painting is less densely painted—notably the lower left corner—show that the preliminary working on the canvas was softer and less regimented; the very taut ordering of the surface was added as Cézanne worked the picture more fully. Thus, it was not an order that he found in the natural subject in front of him, but rather something that he imposed during the process of transforming his experiences of nature into a two-dimensional painting. His comrade Pissarro, with whom he painted regularly until the early 1880s, was also using crisp, rhythmic brushstrokes to unify his paint surfaces at this time, but he never gave them as rigid and geometric a structure as Cézanne (see Colorplate 32).

Houses in Provence was painted in the south of France, probably near the coastal village of L'Estaque, west of Marseille. It reflects Cézanne's efforts to capture the brilliant light of the Mediterranean both in its crisp lighting and in the repeatedly juxtaposed accents of orange-yellow and blue that he used to emphasize the contrasts between adjacent patches of light and shade between the roofs and the sky, and between the little window shutter and the sunlit wall on the left house.

Colorplate 16.
Houses in Provence.
1880.
65 × 81.3 cm
(25⅝ × 32 in.)
Collection of Mr. and
Mrs. Paul Mellon, 1973

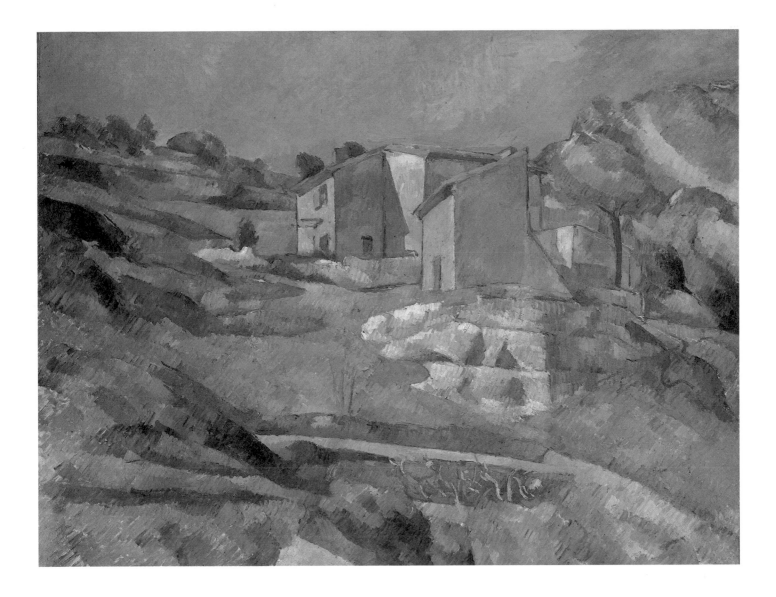

STILL LIFE WITH PEPPERMINT BOTTLE
PAUL CÉZANNE

Still-life painting fascinated Cézanne throughout his career, and in this type of subject his changing preoccupations can perhaps be seen most fully, because still life gave him the freedom to choose and arrange the combinations of objects he wanted to depict. A witness described his process of setting up one such still-life subject: "The cloth was draped on the table, with innate taste. Then Cézanne arranged the fruits, contrasting the tones one against the other, making the complementaries vibrate, the greens against the reds, the yellows against the blues, tipping, turning, balancing the fruits as he wanted them to be, using coins of one or two *sous* for the purpose. He brought to this task the greatest care and many precautions; one guessed it was a feast for the eye to him."

His earlier still lifes generally show fairly simple groupings, viewed frontally on tables, but by the 1890s he was arranging far more complex subjects. In *Still Life with Peppermint Bottle,* the legs of the table that supports the still life are largely hidden by the sweeping curves of the patterned blue cloth; across this, in turn, a white cloth is folded on the left. The solid objects—glass, bottles, and fruit—nestle amid these deep folds; nowhere are any of them shown resting firmly on a horizontal surface.

The still life is thus arranged to avoid the traditional equilibrium of objects at rest, which is replaced by an equilibrium of a different sort between the forms and colors within the picture. The curves create a lavish interplay in the center of the painting, and the horizontals and verticals nearer the edges—the table legs and the patterns on the wall beyond—anchor the arrangement within the frame. Blue is the dominant color, but the blues are varied with nuances of green and mauve and revolve around the brighter warm hues of the fruit and the labels on the peppermint bottle. The still-life arrangement he set up gave Cézanne the raw materials for his painting, but it was in the final painting itself, within its two-dimensional confines, that he created this grand interplay of forms and colors.

Colorplate 17.
Still Life with Peppermint Bottle.
circa 1894.
65.9 × 82.1 cm
(26 × 32⅜ in.)
Chester Dale Collection, 1962

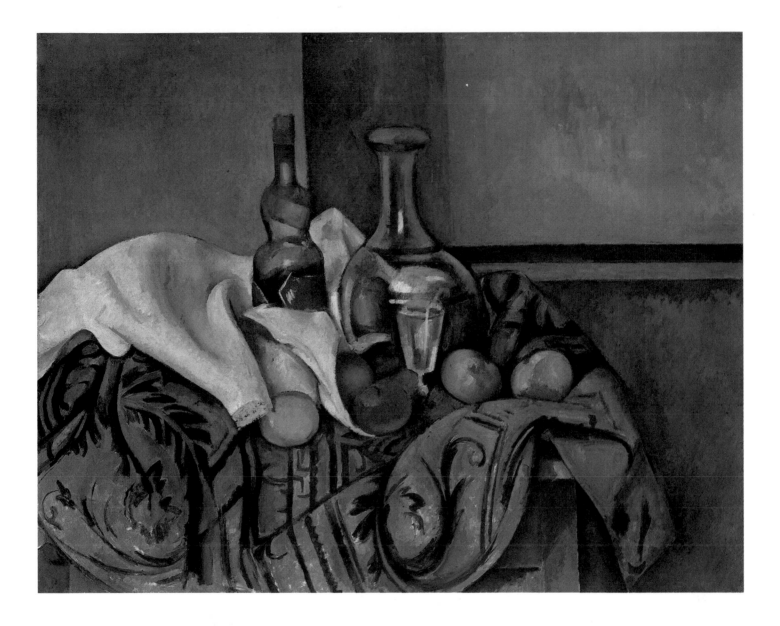

LE CHÂTEAU NOIR
PAUL CÉZANNE

From the later 1880s until after 1900, Cézanne did much of his painting in the countryside to the east of his hometown of Aix-en-Provence in the rocky hills around the Château Noir, a large house where he rented a room. *Le Château Noir* is one of a sequence of paintings in which he depicted the house with its terrace and the tree-clad slopes around it.

Here the house is tightly framed by trees—the mass of pines on the left and the intruding tentacles of the branches that reach out toward the building from the right. The rich orange tones of the house and the terrace stand out strongly amid the dense greens and blues around them, but throughout the picture, warm hues—oranges and reds—are threaded through areas that are predominantly dark and cool, and the forms of the sunlit buildings are suggested by cool blues.

The tightly interlocked shapes in the picture were present in Cézanne's chosen natural subject, but he emphasized their coherence in the way he painted it as a means of achieving his declared aim to "revivify Poussin in front of nature." His transformation of a natural subject into a work of art gave to nature the clarity and richness of form that he so valued in the art of the great masters of the past, such as Poussin and Rubens, whose work he continued to study.

Unlike many of his later paintings, *Le Château Noir* is thickly and elaborately reworked. The placing of some of the branches in particular bears witness to the ceaseless revisions through which he sought to realize his aims more fully. From this protracted process of elaboration and modification emerged one of the most powerful and sonorous of his late landscapes.

Colorplate 18.
Le Château Noir.
1900–04.
73.7 × 96.6 cm
(29 × 38 in.)
Gift of Eugene and
Agnes Meyer, 1958

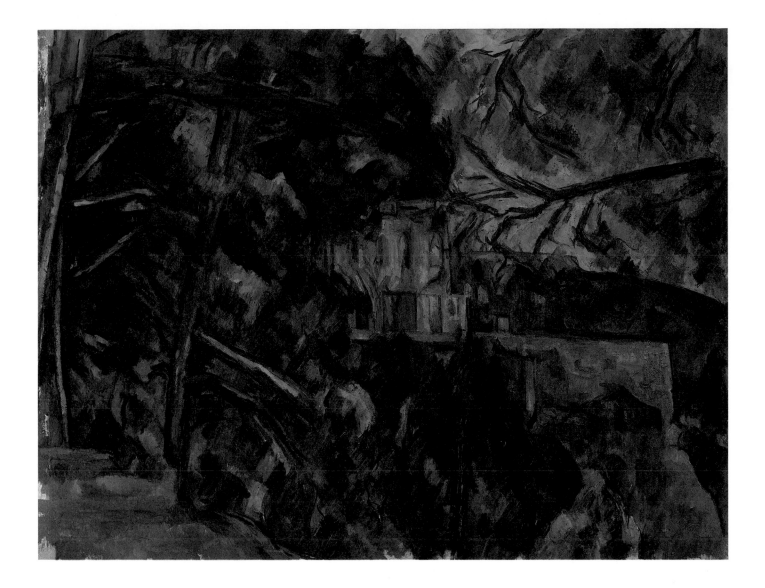

THE SAILOR
PAUL CÉZANNE

This is one of a group of ambitious portraits Cézanne painted in the last few years of his life; the sitter for them has been identified variously as a sailor or the gardener Vallier, though one friend saw his features as echoing those of the painter himself.

The surface is thickly reworked; indeed, the model around the head stands out from the canvas in a sort of low relief, the result of the countless superimposed layers of color Cézanne added to the canvas as he felt his way toward the figure's definitive form. The picture is less thickly painted, though, along a band across the base; this is a strip of canvas Cézanne added during the execution (the junction of the pieces of canvas is clearly visible). This addition gives the painting a particularly elongated format, placing the sitter's head unusually high within the painting's total height; it shows how Cézanne sought to increase the figure's monumentality while at work on the canvas, giving the image a grandeur wholly transcending the apparently modest status of the sitter.

In color, the painting is quite somber, dominated by the deep hues of the old man's clothes; the greens of the background beyond him are set off against the warm hues of his face and hands. The color and densely worked surface invite comparison with *The Artist's Father,* which was painted almost forty years earlier (Colorplate 14). In place of the limited color of the earlier picture, *The Sailor* contains endless colored nuances—in the background and the flesh modeling and even in the sitter's dark jacket and trousers—and in place of the crude palette-knife work of *The Artist's Father,* the surface of the later painting is built up with successions of varied touches and strokes, often of great delicacy. Every part of its surface is enriched by these variations of color and touch.

Colorplate 19.
The Sailor.
circa 1905.
107.4 × 74.5 cm
(42¼ × 29⅜ in.)
Gift of Eugene and
Agnes Meyer, 1959

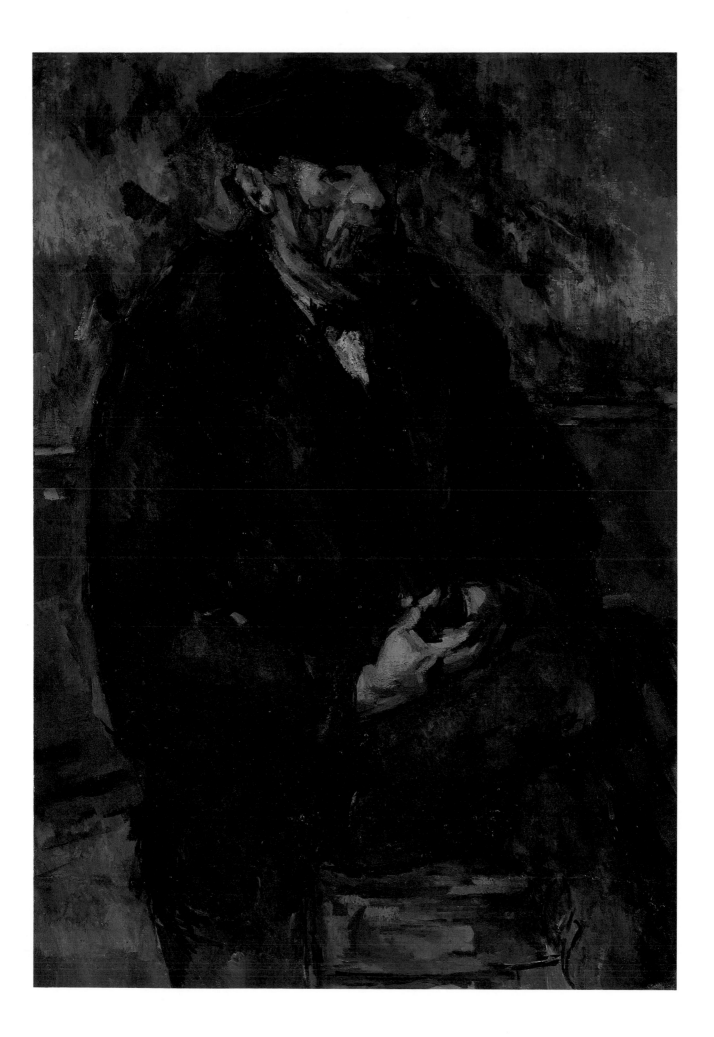

DIANA
AUGUSTE RENOIR (1841–1919)

Early in his career, Renoir sought a public reputation with various types of painting: portraits, still lifes, and ambitious subject pictures like *Diana*. He submitted *Diana* to the official Salon in Paris in 1867. He later said that he had wanted to submit a simple study of a female nude but had added the bow and the dead deer to change the subject to the ancient goddess Diana, hoping that this would make the picture more acceptable to the Salon jury. Nevertheless, the picture was rejected. The story cannot have been exactly as Renoir recounted it, because the whole pose of the figure revolves around the bow and the deer, which are clearly essential to the arrangement of the picture. But even if these references to classical mythology are integral to the subject, the treatment of the figure shows Renoir's allegiance to a realist style of painting; weighty and broadly handled, quite unlike the smooth neoclassical ideal favored by the Salon juries. *Diana* reveals Renoir's interest in the art of Gustave Courbet, who had won considerable success at the previous year's Salon with *Woman with a Parrot* (Metropolitan Museum of Art, New York), a reclining nude with discarded modern clothing. *Diana* was also one of Renoir's first paintings to show Lise Tréhot, who was for several years his companion and principal model; he painted her again in 1870 in *Odalisque* (Figure 2).

In its technique, too, Renoir's picture shows his allegiance to Courbet; much of it is treated with broad sweeps of the palette knife, Courbet's favorite painting instrument. This gives the background a very flat and simplified effect; its space is hard to read clearly. The deer and the figure are also painted mostly with the knife but are treated in such a way that they appear strongly three-dimensional—almost standing out from the surface of the picture—when seen from a distance.

The contrast between the painting's mythological subject and its fluent handling and realistic treatment reveals Renoir's ambition to fuse direct observation with the traditions of past art, an ambition he was to realize more fully in later paintings such as *Bather Arranging Her Hair* (Colorplate 25).

Colorplate 20.
Diana. 1867.
199.5 × 129.5 cm
(77 × 51¼ in.)
Chester Dale Collection,
1962

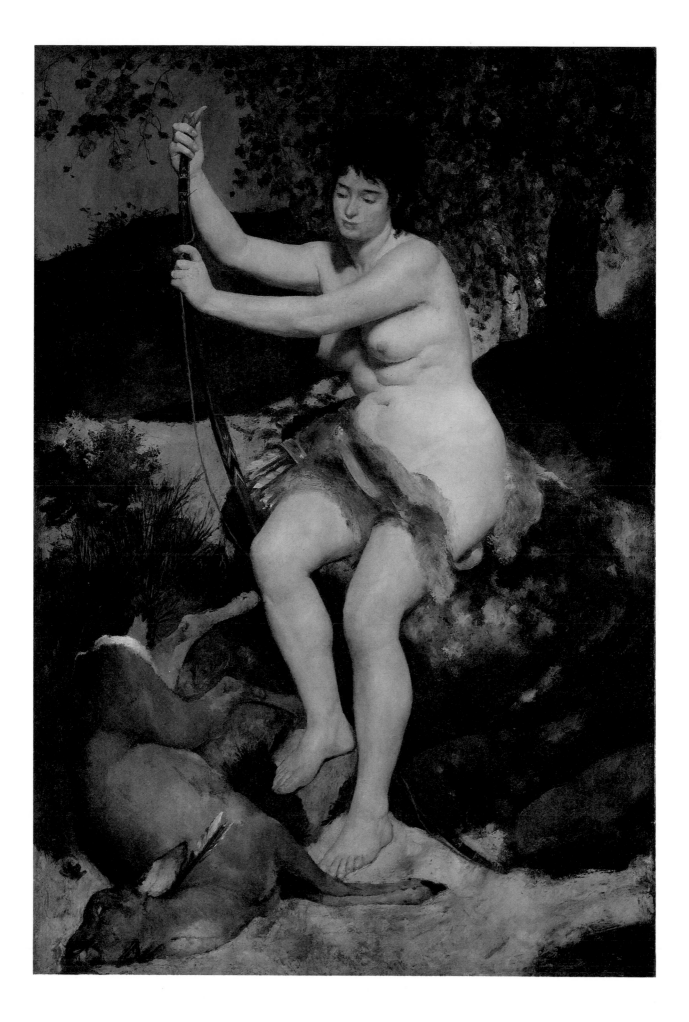

PONT NEUF, PARIS
AUGUSTE RENOIR

Renoir painted this view of the Pont Neuf, the oldest sur-
viving bridge across the Seine in Paris, from an upstairs
window. This allowed him to look out over the scene
from above in order to capture the animation of the traffic and
the figures. Renoir's brother Edmond recalled the expedient that
had enabled Renoir to paint the scene: while Edmond, down on
the street, stopped people to ask them a casual question, the
painter quickly noted them on his canvas.

When the painting is seen from a distance, the crisp lighting
and varied activity seem to be rendered with some precision, but
up close, one sees how economically they are treated. Cos-
tumes and gestures are suggested by dabs and flecks of color that
well characterize the types of figure shown, but quite without
sharp detail. Lively, fluent brushwork runs throughout the pic-
ture, animating buildings and sky and adding to the vitality of the
scene.

The color is very simple, dominated by blues and soft yel-
lows; even the shadows of the foreground figures and the shaded
river embankments are clearly blue in hue. Here Renoir vir-
tually abandoned black, even for dark costumes; the figures are
all absorbed into the sunlit atmosphere pervading the whole
scene. A few accents of red on figures and omnibuses pick up
the red in the French flag on the right. But alongside this re-
minder of French nationhood, nothing in the lively scene hints
at the city's recent misfortunes: the Prussian occupation and the
bloody suppression of the Commune in 1870–71. The sunlit
surface of everyday life had resumed, irrespective of these mo-
mentous events.

When Renoir included *Pont Neuf, Paris* in the auction sale that
he and his friends organized in 1875, it fetched three hundred
francs, more than any of his other paintings in the sale; when it
appeared again at auction in 1919, it was sold for one hundred
thousand francs.

Colorplate 21.
Pont Neuf, Paris.
1872.
75.3 × 93.7 cm
(29⅝ × 36⅞ in.)
Ailsa Mellon Bruce
Collection, 1970

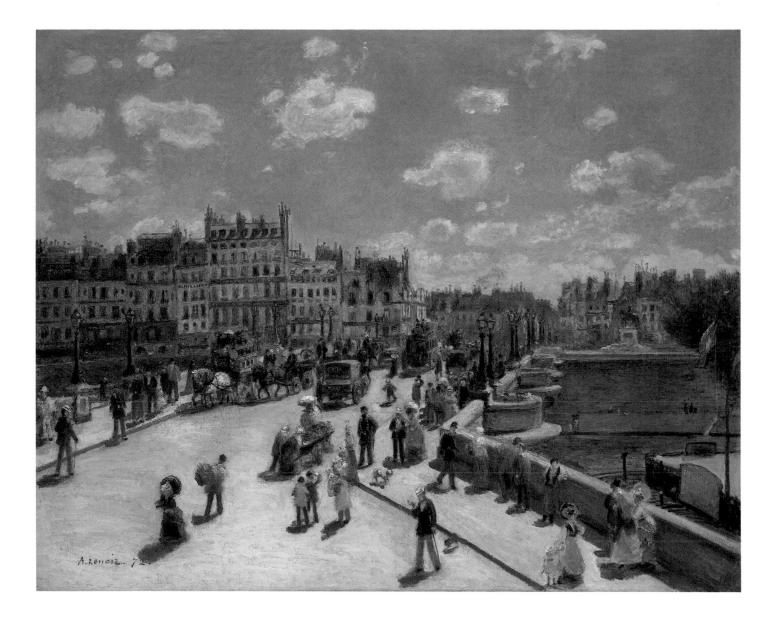

A GIRL WITH A WATERING CAN
AUGUSTE RENOIR

Alongside the freshly painted outdoor scenes such as *Pont Neuf, Paris* (Colorplate 21), which gave impressionism its early reputation, Renoir continued to paint commissioned portraits during the 1870s. *A Girl with a Watering Can* was presumably a commission, though nothing is known of the little girl or her family. Her watering can and the daisies she holds give the painting an informal air, suggesting that she is going about some purposeful business in the garden. But her static pose and absented gaze out of the picture show that she was carefully posed, like one of Velásquez's child portraits of the Spanish royal family translated into modern dress and a modern setting.

Renoir's brushwork is soft and feathery throughout, and the color is constantly varied. The girl's blue dress stands out clearly from the green of the grass beyond, but her hair and legs blend slightly around their margins with what lies beyond, and the plants and flowers of the garden are woven into a single sequence of delicately colored touches. Related colors recur throughout the picture, with soft blues, greens, mauves, and yellows revolving around the sharper blue of the dress and the reds of the ribbon in her hair and the flowers alongside it.

The picture's busy, almost fussy surface shows that Renoir was pursuing a far greater degree of finish in this portrait than in *Pont Neuf, Paris* (Colorplate 21). However, the constant small colored touches lead to a blurring of the figure's forms. This technique was suited for subjects where the figures could be absorbed into their natural setting, such as *The Swing* (Jeu de Paume, Paris), painted in the same year, but was less appropriate for a commissioned portrait, with its expectations of verisimilitude. It was in part the demands of portraiture that encouraged Renoir over the next ten years to reintroduce far more precise drawing into his art, for instance the 1885 *Girl with a Hoop* (Colorplate 24)

Colorplate 22.
A Girl with a Watering Can. 1876.
100.3 × 73.2 cm
(39½ × 28¾ in.)
Chester Dale Collection, 1962

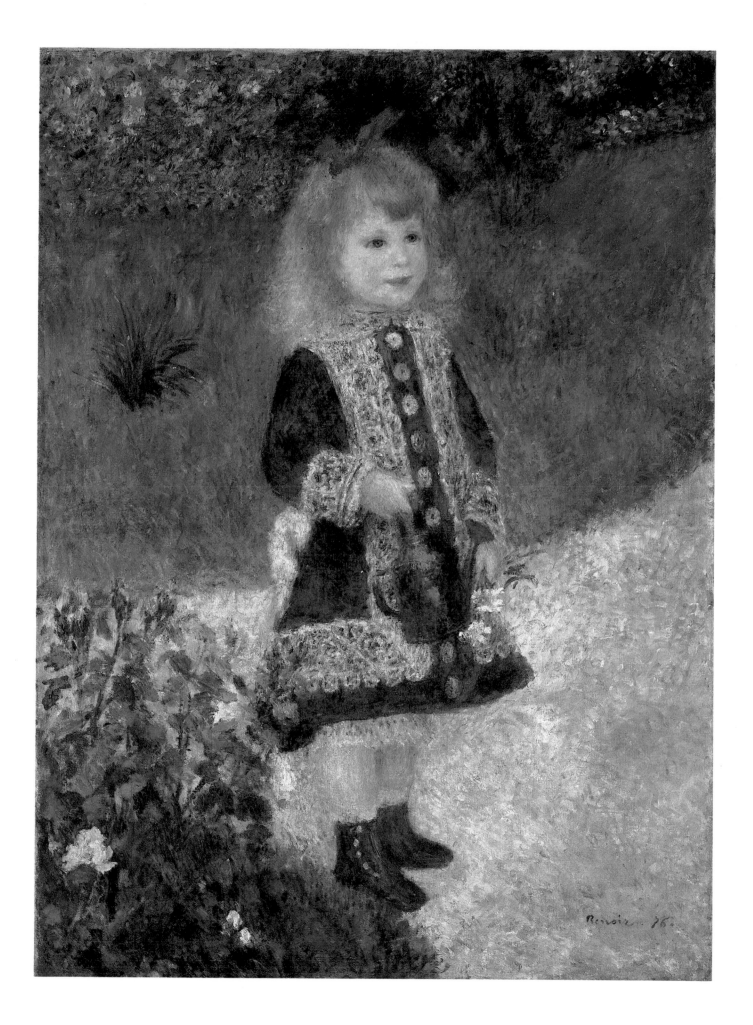

OARSMEN AT CHÂTOU
AUGUSTE RENOIR

Around 1880 Renoir often painted at Châtou, a village on the Seine about ten miles west of Paris, a well-known center for boating and canoeing, which were fashionable leisure activities. While he was working there, he stayed at the Fournaise restaurant on an island in the Seine, and at this restaurant he sited his most ambitious river scene, *The Luncheon of the Boating Party* of 1880–81 (Phillips Collection, Washington, D.C.). *Oarsmen at Châtou* is one of the smaller, more informal scenes he painted there which show the variety of the river life: a cargo barge and a sailboat in the background, together with the skiffs that dominate the picture. The model for the man in the light jacket was apparently Renoir's friend Gustave Caillebotte, a fellow artist who assembled one of the first important collections of impressionist paintings, and the woman is said to have been modeled by Aline Charigot, whom Renoir was later to marry; this may be the first of his paintings in which she appears.

It is a freely sketched canvas. The surface is enlivened by varied, emphatic brushmarks, with some parts of the scene only rapidly indicated; the standing figure on the far left is very summary, and the far distance on the left is particularly loosely treated. The uneven degrees of finish in different parts of the painting are quite unlike the fine overall working of *A Girl with a Watering Can* (Colorplate 22).

Renoir's treatment of the reflections in the water makes an interesting contrast to Monet's. Monet was always concerned with recording them as they would be seen, with the broken reflections directly below the forms reflected, as in *Banks of the Seine, Vétheuil* (Colorplate 12). In Renoir's paintings, they are less precisely recorded and are used to create a supple, almost decorative interplay of colors and touches, as in the reflections of the main boat in *Oarsmen at Châtou*.

Renoir's color here is particularly intense. The whole picture is dominated by strong contrasts of blues and oranges that appear at their brightest in the opposition between the main boat and the water; alongside these sharp colors, all the forms in the picture are treated in constantly varied nuances suggesting the play of sunlight and shadow across them. *Oarsmen at Châtou* is one of the most scintillating impressionist boating scenes.

Colorplate 23.
Oarsmen at Châtou.
1879.
81.3 × 100.3 cm
(32 × 39½ in.)
Gift of Sam A.
Lewisohn, 1951

GIRL WITH A HOOP
AUGUSTE RENOIR

In *Girl with a Hoop,* the figure stands out crisply, demarcated from the background by sharp margins (notably the girl's left cheek) or by contrasts of color and texture. This formal clarity contrasts markedly with the softness and blurring of form of *A Girl with a Watering Can* of 1876 (Colorplate 22); it was the result of a period of experimentation, starting in the early 1880s, in which Renoir sought to introduce crisper drawing into his paintings. In 1881, he even traveled to Italy to study the art of Raphael in his desire to go beyond the apparent formlessness of his impressionism of the 1870s.

The girl's skin in *Girl with a Hoop* is smoothly and precisely painted, but the background foliage is treated with broken, distinct brushstrokes that allowed Renoir to juxtapose varied colors and rhythms. However, in contrast to the soft nuances of color and touch in the background of *A Girl with a Watering Can,* here the brushwork is crisper, with sequences of strokes, often running parallel to each other, organizing the surface more tautly; these parallel strokes are reminiscent of the contemporary work of Cézanne (Colorplate 16), with whom Renoir was closely in touch at this time.

Renoir was no longer interested in specific effects of sunlight, such as those he had shown in *Pont Neuf, Paris* in 1872 (Colorplate 21). The colors here suggest that the sun is shining, but we are not shown the precise play of light and shade or any shadow cast by the girl's figure; instead, the ground is treated in an almost kaleidoscopic sequence of dappled colors that complement those in the foliage and the girl's dress. The atmospheric colors playing across the dress leave us uncertain of the actual colors of its material.

Girl with a Hoop was a commissioned portrait of Marie Goujon, the daughter of a doctor; a paired companion to the picture showing her younger brother holding a toy whip is in the Hermitage Museum, Leningrad.

Colorplate 24.
Girl with a Hoop.
1885.
125.7 × 76.6 cm
(49½ × 30⅛ in.)
Chester Dale Collection,
1962

BATHER ARRANGING HER HAIR
AUGUSTE RENOIR

After the precise contours he had adopted during the 1880s in order to reintroduce form into his pictures (see Colorplate 24), Renoir's handling once again became more fluent and supple during the 1890s. Through a study of Old Master paintings, notably of French eighteenth-century artists such as Fragonard (for example, *A Young Girl Reading,* National Galley of Art, Washington, D.C.), Renoir found a means of suggesting form through the flowing gestures of the loaded brush, using it to follow the contours and rhythms of his subject. In *Bather Arranging Her Hair,* the elaborate folds of the discarded clothing show this clearly in their cursive, flowing lines, but even the figure is treated primarily in soft, fluid strokes that follow her contours and modeling. The patterns of the drapery complement and frame the figure to produce a carefully arranged and densely filled overall composition.

By this time Renoir was less interested in distinctively modern subjects; the clothing seems to be contemporary, but he focuses on its patterns and colors, not on fashionable details. The principal subject of the painting, the female nude, belongs to a long tradition of timeless images of beauty; Renoir emphasized that the figure is to be seen less as an individual than as a type by treating her facial features with much less detail than her body.

Renoir was no longer focusing on fleeting effects of falling light, as he had in the 1870s; the shadows on this figure are largely colorless, and those on her white towel are gray. The generalized natural background, too, has very restrained color. Undistracted by the impressionist preoccupation with atmospheric nuances, he was free to concentrate on a single dominant color effect, using the whites, pinks, and yellows of the draperies to frame and enhance the soft warm coloring of the bather's flesh. Paintings like this establish Renoir's claim to belong to the great tradition of European figure painting; in his later years, he paid particular homage to Titian and Rubens, the two great masters of the freely painted sensuous female form.

Colorplate 25.
Bather Arranging Her Hair. *1893.*
92.2 × 73.9 cm
(36⅜ × 20⅛ in.)
Chester Dale Collection, 1962

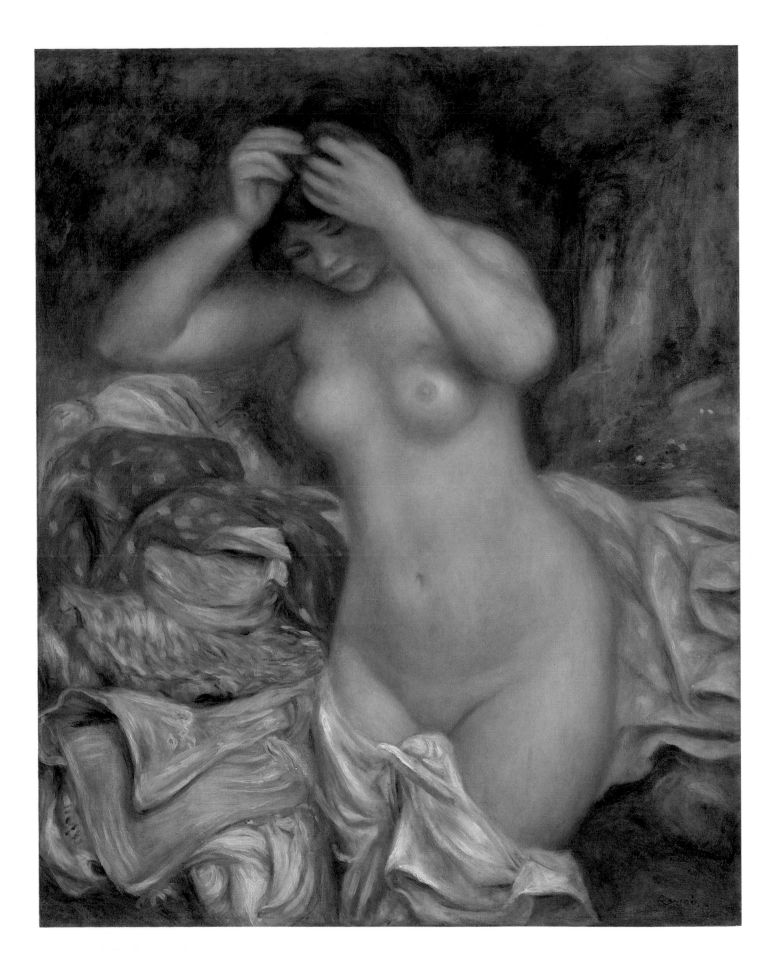

THE HARBOR AT LORIENT
BERTHE MORISOT (1841–1895)

This canvas was painted in the summer of 1869, the year after Morisot had met Manet; that same spring, she had appeared on the walls of the Salon as one of the models for his painting *The Balcony* (Jeu de Paume, Paris). Manet never formally taught Morisot but soon became her mentor. However, *The Harbor at Lorient* shows that at this date she had gone further in the rendering of open-air light effects than had Manet. She had studied with Corot in the early 1860s, and the delicate, pearly palette recalls his; the simplified yet crisply indicated forms of the background buildings can also be compared with his open-air studies. The light is recorded with great freshness and clarity, but the picture is also very carefully organized around the sequences of crisp, darker accents punctuating its luminous space: the trees, the hulls of the boats, and the hat of Morisot's sister Edma, seated on the wall to the right.

Manet was much impressed by *The Harbor at Lorient* when Morisot brought it back to Paris, and she at once presented it to him; her vision of open-air effects, as much as his contacts with the young impressionists, probably helped him lighten his palette in the early 1870s (see Colorplate 3).

The subject of *The Harbor at Lorient* is quite up-to-date, with Edma's fashionably dressed figure seated on the harbor wall of this port in southern Brittany. The presence of the Morisots on holiday there in 1869 reflected a major change in the area. Only after the recent opening of the railway lines did this far northwestern corner of France become readily accessible to tourists from Paris; the Brittany tourist industry dates from then. Boudin's Trouville pictures (see Colorplate 7) similarly celebrate the arrival of the fashionable tourist on the Channel coast in Normandy.

Colorplate 26.
The Harbor at Lorient.
1869.
43.5 × 73 cm
(17⅛ × 28¾ in.)
Ailsa Mellon Bruce
Collection, 1970

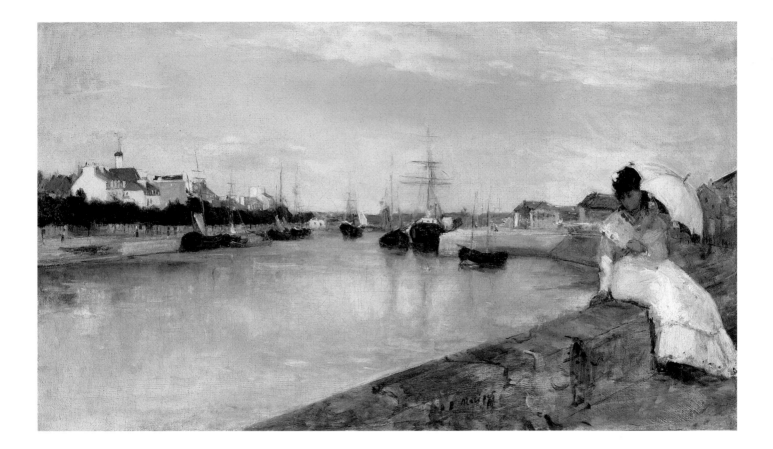

MADAME CAMUS
EDGAR DEGAS (1834–1917)

In the 1860s and early 1870s, Degas devoted much of his attention to portraiture. His sitters were mostly relations or close friends; this freed him from the limiting pressures of patronage, with its demand for conventional likeness and flattering depiction. Thus, Degas was left free to explore a whole range of means for expressing personality and human relationships. He was particularly fascinated by the passing gestures and apparently casual poses that seemed to him to sum up his sitters, and he experimented with unexpected angles of vision and effects of lighting that enhance the effects he sought.

Although Madame Camus is seen in profile, she is not formally posed but leans forward as if alert to something or someone we cannot see. Her gesture is caught not by the traditional means of placing a lit, focused face against a neutral background but by lighting her face from beyond and setting its shadowed forms against a glowing red wall, with only the edge of her profile catching the light. This unexpected angle of lighting is emphasized by the crisp shadow cast on the wall by the statuette on the right, the head of which is abruptly cut by the edge of the picture. The luminous pink wedge at the right margin may be the shade on the unseen lamp, but Degas deliberately denies us the information to confirm this. The picture has an unusually strong dominant color, with the light reflected off the red wall complemented by the color of Madame Camus's dress; the sitter and the other objects are all absorbed into a strange, suggestive atmosphere.

Madame Camus is one of the many portraits Degas did not complete to his entire satisfaction; it remained in his studio until his death. Throughout his career he was reluctant to declare any of his works definitively finished. In *Madame Camus,* he may have felt that he could not take the painting any further without disturbing its precarious balance between evocative mood and detailed depiction.

Colorplate 27.
Madame Camus.
1869–70.
72.7 × 92.1 cm
(28⅝ × 36¼ in.)
Chester Dale Collection,
1962

THE RACES
EDGAR DEGAS

Pure nature had little appeal for Degas. Whereas natural landscape was a prime subject of his impressionist colleagues, he rarely painted outdoor subjects and mocked their attempts to paint outdoor pictures that would be viewed in very different indoor lighting. The only outdoor theme he regularly painted was the racecourse, but even here his final pictures were executed in the studio, carefully composed from long sequences of studies. The movements of horses and riders were in a sense the outdoor counterpart of his favorite theme of ballet dancers (see Colorplate 30). In his paintings of races and of dancers, he delighted in juxtaposing movement and rest, the controlled athleticism of the gallop or the dance set alongside the unfocused gestures of waiting riders and dancers, who sometimes rest immobile but often fidget restively.

The Races juxtaposes professional and amateur riders. Jockeys in their brightly colored costumes wait in the foreground, while beyond them, in the center, there are men in top hats on horseback. No race is under way, and no single incident claims our attention. The background, treated in more detail than in most of Degas's race-course scenes, shows smoking chimneys and, to the left, the tiny silhouette of a medieval cathedral. Their shapes are picked up in the foreground; the white posts against the dull green grass closely echo the dark chimneys against the light sky. The subject of the scene is not a particular event or a special view; instead, Degas shows how different, sometimes disparate elements interweave within a characteristically modern scene. Monet, in *Argenteuil* (see Colorplate 9), painted at much the same date, showed comparable interrelationships. The significance of these scenes, as they presented them, lay in their diversity.

Working here on a very small scale, Degas at times used a very fine touch, but like Monet in *Argenteuil,* he did not itemize his forms and figures in sharp detail. All are evoked with simple touches of paint, directing our attention onto the overall effect of the scene and preventing us from reading details of gestures or expression. It is the total effect that gives the scene its modernity.

Colorplate 28.
The Races.
circa 1873.
26.5 × 35 cm
(10½ × 13¾ in.)
Widener Collection,
1942

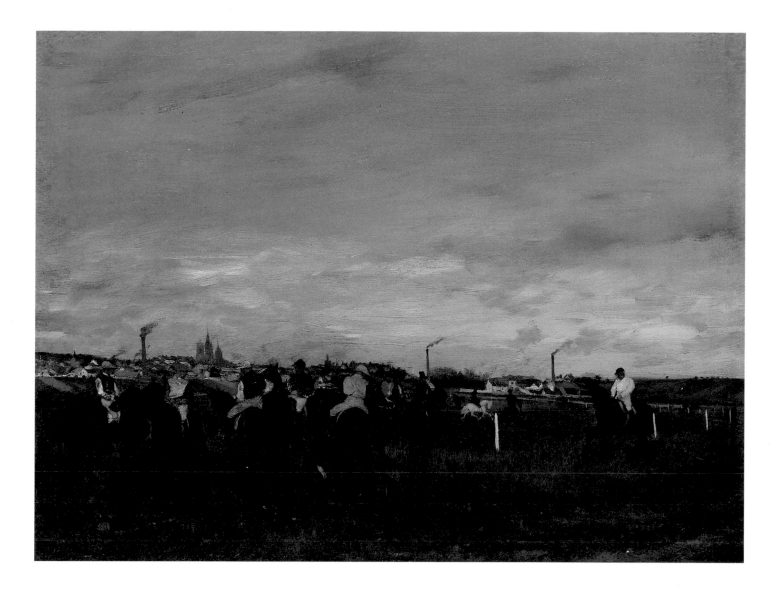

WOMAN IRONING
EDGAR DEGAS

Besides his pictures of ballet dancers (Colorplate 30), Degas made long sequences of studies of various types of working women, notably milliners, laundresses, and women ironing. He scrutinized the most characteristic gestures of each trade, seeking to present them in a pictorial form that would sum up their essential qualities; a friend remembered him describing his observation of women ironing, "speaking their language, explaining to us in technical terms the *applied* stroke of the iron, the *circular* stroke, etc." He always placed these activities in an appropriate setting, often with other figures who suggest other aspects of the subject. Here the woman ironing is shown alone, but in other paintings the working woman is alongside a woman stretching and yawning to emphasize the heat and exhaustion of their task.

This is the latest of the three canvases he painted of this particular composition between about 1874 and 1882; the first is in the Metropolitan Museum of Art, New York. In all of them the woman is placed against the light, with her pose primarily defined by profile and silhouette. The pose of the figure varies little, but in each the setting is very different. Here the surroundings are particularly fully and wittily characterized. The soft shapes across the top of the picture are presumably un-ironed garments hanging down in front of the windows; the white shirt she is ironing is particularly loosely handled, emphasizing how crumpled it is. By contrast, the ironed shirt at the front is treated with great precision, its crisp rectangle topped by the tight circle of its starched collar, which closely matches the shape of the water bowl just beyond it. Our viewpoint is close to the woman, almost looking over her shoulder, but she is unaware of our presence.

The composition is dominated by varied off-whites set against the dark grid of the background windows, but the hanging clothes and the woman's dress and apron set up a rich sequence of varied colors. Degas has combined the figure with its setting, and her closely observed gesture with a tautly structured composition, to produce one of the richest of all his depictions of working women.

Colorplate 29.
Woman Ironing. *1882.*
81.3 × 66 cm
(32 × 26 in.)
Collection of Mr. and
Mrs. Paul Mellon, 1983

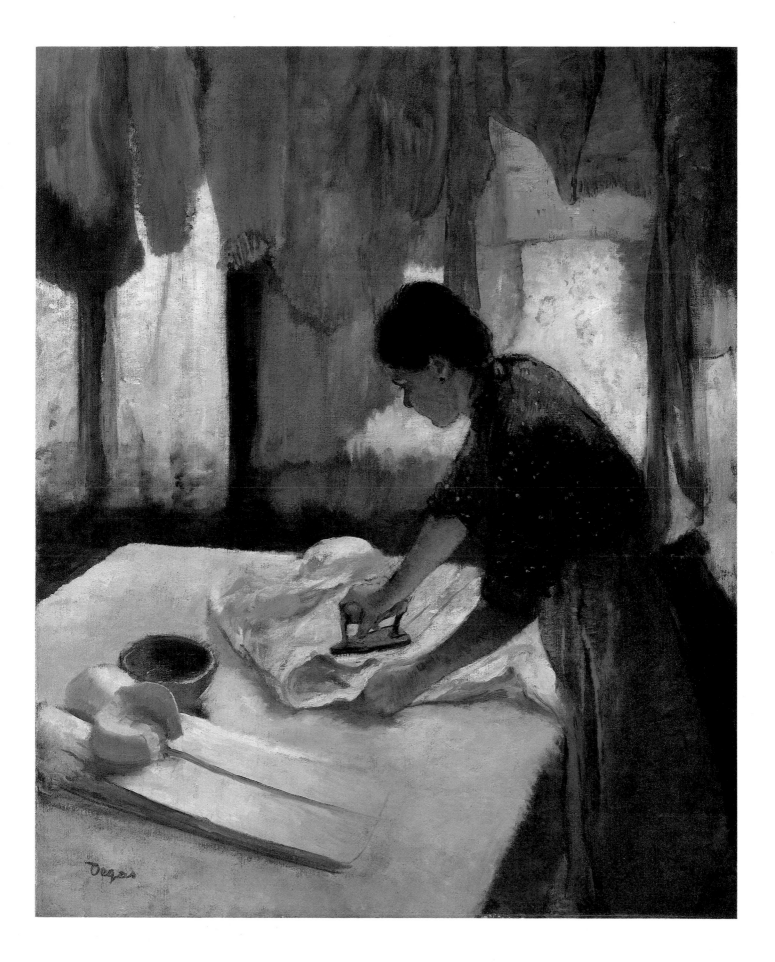

FOUR DANCERS
EDGAR DEGAS

Four Dancers is one of Degas's last and most ambitious explorations of a theme that had fascinated him for thirty years: costumed ballet dancers rehearsing or on stage but caught off guard between their dance movements or between performances. Instead of basing the rhythm of his paintings on the rhythms of the dance, Degas found his raw material in the intervals, the breaks in the formal dance movements, when reflexes and instinctive gestures take over from the unity of the performance; his final compositions were carefully composed from long sequences of studies of individual figures.

The dancers in *Four Dancers* are not performing. Three of them adjust their shoulder straps, but their gestures—repeated turned heads and pointed elbows—are woven into a single pattern as coherent in its way as any formal performance. The setting of the figures is left uncertain. Presumably, the sweeping landscape on the right is a stage set, but it seems to open out into an actual landscape space, a meadow with trees beyond. We are given no clear idea of the placing of this huge stage flat (if stage flat it is), and the location of the dancers, tucked into the bottom left of the picture, is also undefined. There is a contrast between the huge figures at front left and the open space on the right, but the whole picture is given a coherence by the rhyming forms of the dancers' heads and the far trees and by the color scheme, which is based throughout on contrasts between oranges and greens.

At this time Degas was greatly handicapped by poor eyesight and generally worked in pastel, which he found easier to manipulate. Working here in oils, he handled his materials very freely, in loose dabs and broad sweeps of color. In places the painting is clearly left unfinished. The dancers' skirts are left very formless, and around the upper margins of their figures and costumes black painted contours were added at a very late stage to reemphasize or modify their positions; this outlining has not been integrated with the colored paint beneath it. However, the enormous scale of *Four Dancers* and the rich interplay of its shapes and colors establish it as one of the grandest of Degas's late paintings.

Colorplate 30.
Four Dancers.
circa 1899.
151.1 × 180.2 cm
(59½ × 71 in.)
Chester Dale Collection,
1962

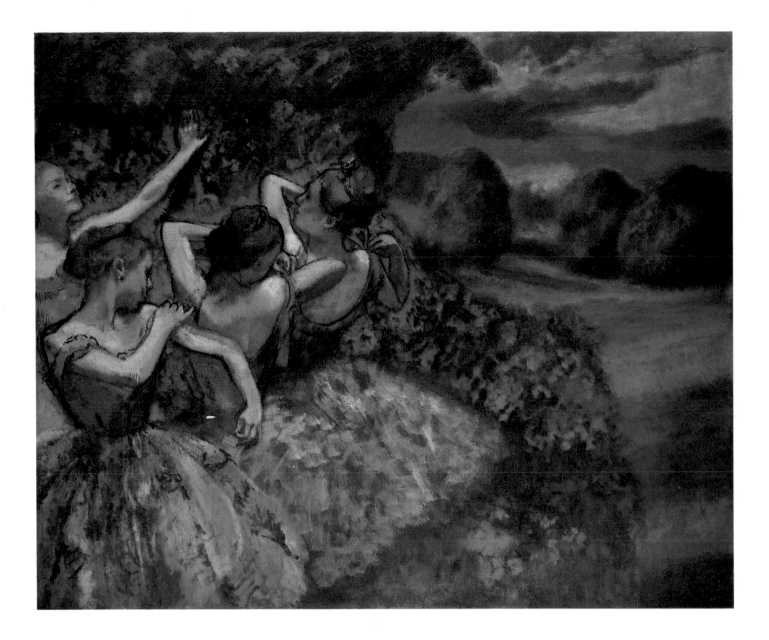

ORCHARD IN BLOOM, LOUVECIENNES
CAMILLE PISSARRO (1830–1903)

Louveciennes, ten miles west of Paris, was near the riverside pleasure haunts of Bougival and La Grenouillère which so attracted Pissarro's friends Monet and Renoir (see Monet's paintings of La Grenouillère in the Metropolitan Museum of Art, New York, and the National Gallery, London). Pissarro favored the more timeless aspects of the area: village streets and, as here, the cultivated countryside. *Orchard in Bloom, Louveciennes* makes nothing of the particular topography of the place; instead, Pissarro chose a typical agricultural scene of fruit trees in blossom while the soil around them is being worked. Figures, trees, and earth all belong in a single, enclosed space, with no hint of the contrasting ways of life that by 1872 characterized the villages and towns around Paris. Monet, by contrast, made much of this diversity in *Argenteuil* (Colorplate 9) painted the same year.

Like Monet in *Argenteuil,* Pissarro painted with simple, varied touches of color through which he could capture the characteristic forms and textures of the objects he saw without being distracted by their details. His handling here is broader and more economical than Monet's, with some areas treated by simple sweeps of paint, but for all their simplicity, these brushstrokes give a very lively suggestion of the effect of the scene. Pissarro was working in this manner when, later in the same year, Cézanne came to work with him in order to learn the techniques of painting from nature (see Colorplate 15).

Pissarro's color is quite restricted in this picture, dominated by soft greens and browns beneath the blue sky. The blues in the clothing of the figures signal their importance in the picture; it is their work that gives such a subject its significance. But they, like the rest of the scene, are treated with great simplicity and presented as a natural part of their surroundings.

Colorplate 31.
Orchard in Bloom,
Louveciennes. *1872.*
45 × 55 cm
(17¾ × 21⅝ in.)
Ailsa Mellon Bruce
Collection, 1970

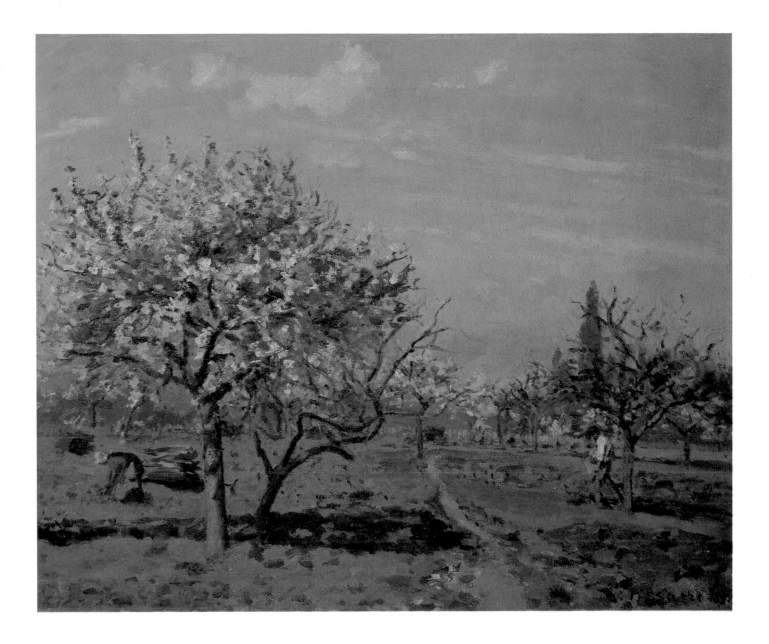

PEASANT GIRL WITH A STRAW HAT
CAMILLE PISSARRO

In contrast to the simple, unassertive handling of his paintings of the early 1870s (see Colorplate 31), Pissarro was by 1880 using a busy, small-scale touch throughout his more finished paintings. In *Peasant Girl with a Straw Hat,* this is most prominent in the background, where serried ranks of crisp little strokes evoke the textures of the foliage and introduce continuous variations of color—soft pinks and blues alongside the varied greens—to suggest the play of light and shade. But even in the figure, the surface is varied throughout, with soft, feathery touches describing the girl's skin and constantly shifting tones of pink, purple, green, blue, and yellow expressing the shadows and reflected lights on her face.

This very active, small-scale brushwork allowed Pissarro to introduce far more varied colors than he had ten years earlier, but the repetitive rhythms of the touch also gave the painting an internal order and coherence that can be compared with the effects Cézanne was seeking at the same time (see Colorplate 16); he and Pissarro continued to work together regularly until the early 1880s. The delicacy of Pissarro's flesh painting here, though, is more reminiscent of Renoir's work of the later 1870s, such as *A Girl with a Watering Can* (Colorplate 22).

The dealer Durand-Ruel began to buy Pissarro's paintings regularly in 1881, allowing the artist to pay peasant women to sit as models for pictures such as this; for several years before, only his shortage of money had prevented him from embarking seriously on such subjects. In these peasant paintings, Pissarro regularly showed the women in enclosed spaces, sometimes working or resting from work but often, as here, sitting inactive but seemingly pensive. This interaction between simple country women and the surroundings of their work and life was an expression of Pissarro's vision of a harmonious rural society; he was deeply committed to a peaceful form of anarchist philosophy and saw this as the most humane and rational form of life.

Colorplate 32.
Peasant Girl with a Straw Hat. *1881.*
73.4 × 59.6 cm
(28⅞ × 23½ in.)
Ailsa Mellon Bruce
Collection, 1970

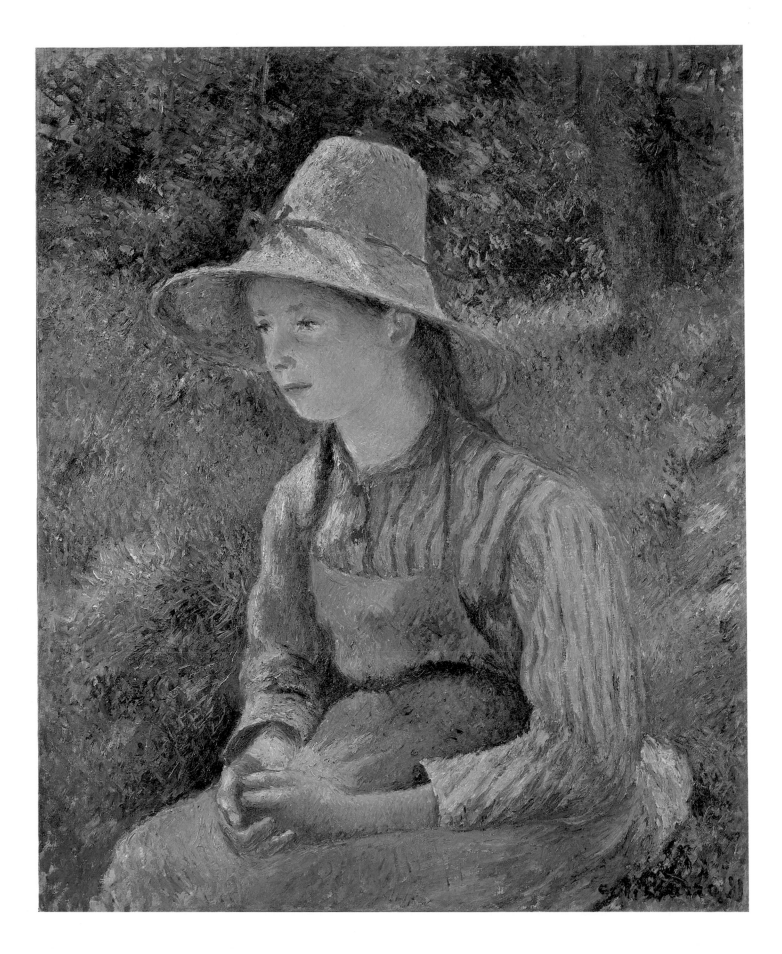

BOULEVARD DES ITALIENS, MORNING, SUNLIGHT
CAMILLE PISSARRO

From the mid-1890s onward, Pissarro painted long sequences of city scenes, some in Rouen but many in Paris, showing both the celebrated monuments of these places (Rouen Cathedral, the Louvre palace by the Seine) and more modern aspects of the city. Here he painted one of the great boulevards created in the modernization of the center of Paris planned by Baron Haussmann from the 1850s onward.

In his paintings of peasant subjects (see Colorplate 32), Pissarro had regularly placed himself close to his models and had set them in enclosed spaces, evoking perhaps the close-knit life of small rural communities. In his city scenes, by contrast, he distanced himself from his subjects by painting from upstairs windows. Such high viewpoints were, of course, necessary in order to see out over the bustling life of the street, but they were also an expression of his vision of the distinctive qualities of urban life: its dispersed, unfocused quality and the separateness of its people.

In *Boulevard des Italiens, Morning, Sunlight,* the points of attention are scattered all across the lower half of the picture, without any central focal point; it is the bustle of the people, the carriages, and the omnibuses, all going in different directions with different purposes, which is his subject and which forms the spectacle. Unlike the peasant figures, none of the people here are represented as individuals.

The color of the picture is dominated by grays and browns, characteristic of the urban scene. But when its surface is seen from up close, it is enlivened by sharper red accents and by nuances of green and blue, while bolder streaks of cream-colored paint capture the morning sunlight raking across the pavement on the right. The picture's subject and surface both give it great vivacity.

Colorplate 33.
Boulevard des Italiens,
Morning, Sunlight.
1897.
73.2 × 92.1 cm
(28⅞ × 36¼ in.)
Chester Dale Collection,
1962

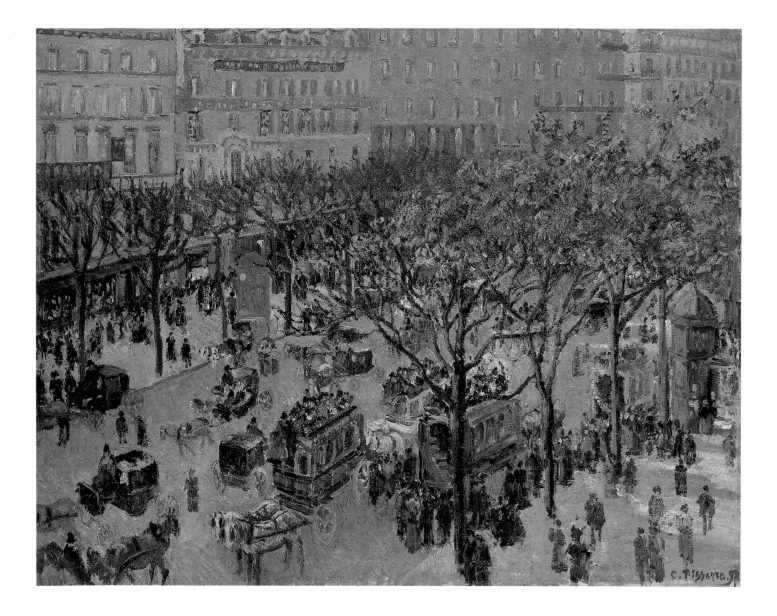

MEADOW
ALFRED SISLEY (1839–1899)

Alfred Sisley was one of the central members of the impressionist group in the 1870s; during this decade he produced some of the freshest impressionist landscape paintings. Early in the 1870s he, like Pissarro (see Colorplate 31), had painted with a simple, varied touch, often producing paint surfaces of great economy. But by the middle of the decade, as in *Meadow,* he had begun to animate his paintings far more, responding to the multifarious textures of the natural scene with small-scale, constantly variegated brushwork. Here, broken, feathery touches enliven the sky, but the main activity is reserved for the foreground in the succession of colored dabs and dashes conveying the grasses and flowers and in the rippling horizontals and verticals of the wooden fence. The two little figures in the center are suggested with simple dabs of color alone but provide an unobtrusive focus amid the natural animation.

The color is dominated by greens, which are constantly varied in order to express the different sorts of grass and foliage; these are set against warmer accents, the sequences of soft pinks and beiges that recur across the canvas and the few crisp red accents of the flowers. But throughout the picture Sisley also introduced occasional soft nuances of blue that hint at the unifying effect of the atmosphere and pick up the color of the sky.

The view Sisley shows in *Meadow* is unspectacular: open countryside without any obvious picturesque features. But this simple scene is transformed by the way in which it is treated; its endlessly mobile surface evokes the vivacity and freshness of nature itself.

Colorplate 34.
Meadow. *1875.*
54.9 × 73 cm
(21⅝ × 28¾ in.)
Ailsa Mellon Bruce
Collection, 1970

HIDE AND SEEK
JAMES TISSOT (1836–1902)

In the 1860s James Tissot became a close friend of Manet and Degas and emerged as one of the leading young painters in Paris who concentrated on scenes from fashionable modern city life. He moved his base to London in 1871 after the overthrow of the Paris Commune, with which he had apparently been implicated. In London he gained a reputation for figure scenes set in fashionable interiors or on board ships, but he remained in close contact with his colleagues in Paris.

In *Hide and Seek* he used a composition of great complexity to evoke the experience of the little child, who is seeking her friends amid the close-packed furniture and decorative bric-a-brac of a typically prosperous late nineteenth-century interior. The smiling faces of the hiding children peep over the furniture and the screen on the left, but as if to mock her efforts to find them, a set of Japanese masks—smiling too—hang beside the door on the right. In the background a woman sits quietly, reading by the light from the window.

Tissot's brushwork is fine and is precise enough to itemize the contents of the room in considerable detail, from the child's ball at the bottom right to the disconcertingly angled reflections in the mirrors on the back walls. Certain details are brushed with great deftness, particularly the hair and the ribboned dress of the little girl on the carpet where they are caught by the light, and the flowers and trees in the garden outside the window. Despite its elaboration, the effect remains very fresh.

The picture's composition, with a bold diagonal across the foreground and open spaces on the right side, is similar to devices Degas often used at this period, but Tissot uses them to a different effect. The low viewpoint enables us to see the scene as if from the child's viewpoint, and the dense accumulation of objects around her constitutes a delightful recreation of a small child's experience of the adult world.

Colorplate 35.
Hide and Seek.
circa 1877.
73.4 × 53.9 cm
(28⅞ × 21¼ in.)
Chester Dale Fund

LITTLE GIRL IN A BLUE ARMCHAIR
MARY CASSATT (1845–1926)

Cassatt came from a prosperous Pennsylvania family that encouraged her artistic ambitions. She traveled widely in Europe, visiting Paris, the Low Countries, and Madrid before finally settling in Paris late in 1873; although she continued to travel, she made her base in France for the rest of her life. She exhibited at the Paris Salons from 1872 to 1876, but in 1877 she met Degas, whose work she already much admired; he introduced her to the impressionist group, at whose exhibitions she showed her work from 1879 onward.

Little Girl in a Blue Armchair was painted the year after she met Degas, and its composition shows his influence. Large forms, placed close to the viewer, are cut by the edges of the picture, and there is an abrupt break between foreground and background instead of a measured recession into space. But Cassatt put these devices to a different use than did Degas. Like Tissot in *Hide and Seek* (Colorplate 35), she exploits them to evoke a child's view of the world, but instead of Tissot's almost anecdotal scene of play, here the mood is quiet and pensive. The girl is sprawled out on one of a set of adult-size patterned blue armchairs, surrounded by its ample form; the little dog is still more enveloped by the chair on the left. Beyond them another chair and a sofa, both empty, stand at the far end of the room like sentinels from the adult world.

Cassatt's brushwork is reminiscent of Manet's, crisp and incisive on the chairs, freely brushed yet softer on the child's skin (see Colorplate 3). The sharp contrasts between dark and light tones on the child's clothes make her the clear focus of the picture amid the blue chairs, but the red accents on chairs and clothes alike give the canvas an overall coherence. The contrasts of scale and the wittily observed gestures make this an evocative image of a child in adult surroundings.

Colorplate 36.
Little Girl in a Blue
Armchair. 1878.
89.5 × 129.8 cm
(35¼ × 51⅛ in.)
Collection of Mr. and
Mrs. Paul Mellon, 1983

THE BOATING PARTY
MARY CASSATT

Images of women and children constitute one of the central subjects of Cassatt's art. In her hands the traditional imagery of Madonna and Child is secularized and translated into everyday images of modern women nursing, washing, dressing, and tending children. Usually they are placed indoors, sometimes in gardens; here, by contrast, a man is rowing them out to sea. Cassatt painted the picture at Antibes, on the Mediterranean coast in the south of France; presumably she executed it indoors from smaller studies and drawings.

The sweeping arc of the boat cutting into the picture and the rhyming curves running throughout the composition are clearly indebted to Japanese color prints, which Cassatt was studying particularly closely at this time, but the placing of the boat is also a direct reference to a celebrated painting by Manet, *Boating* (Metropolitan Museum of Art, New York), which Cassatt particularly admired. In Manet's picture, the figures are very similarly placed against a simple plane of blue water, but there is no legible relationship between them. Here the oarsman looks into the picture toward the woman and child; his figure on the right and the curving sail on the left frame their figures and direct the viewer's eye toward them.

The painting's technique, too, reflects Cassatt's interest in Japanese art, with its simple areas of quite flat, clear color with crisply drawn outlines, in contrast to the more freely brushed, variegated surfaces of her earlier works, such as *Little Girl in a Blue Armchair* (Colorplate 36). Cassatt had recently executed a series of color prints whose composition and technique were particularly reminiscent of the Japanese, and here she emulates their effect in oil paint.

The gestures of the figures are suggested with great precision—the woman restraining the wriggling child and the man leaning forward to pull on the oars—and are combined to create a taut and richly patterned composition.

Colorplate 37.
The Boating Party.
1893–94.
90.2 × 117.1 cm
(35½ × 46⅛ in.)
Chester Dale Collection,
1962

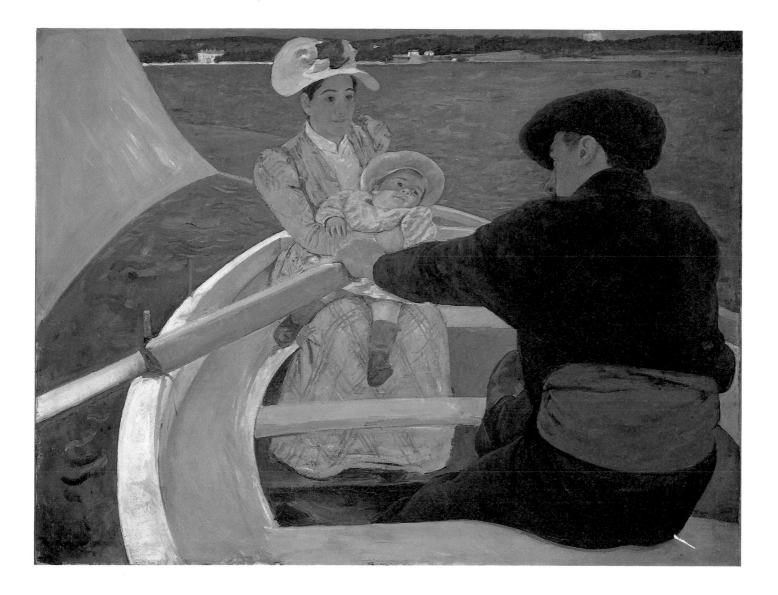

THE LIGHTHOUSE AT HONFLEUR
GEORGES SEURAT (1859–1901)

Like the outdoor painters among the impressionists, such as Monet, Seurat wanted his landscapes to evoke the play of natural light. However, he felt that the impressionists' technique, with its active, varied brushwork, did not allow the painter sufficient control over his or her effects. He described them as "romantic" impressionists, while he by contrast intended to be "scientific"; he adopted the small dot, or point, of color as his basic unit of brushwork in order to control as precisely as possible the quantities of each color that he needed to achieve the effects he sought.

The Lighthouse at Honfleur is among the first landscapes in which Seurat used this technique. Only parts of it are subdivided into dots: the areas where the lighting or the natural textures demanded the introduction of a variety of color. Thus the open, sunlit beach is treated more broadly, in light, creamy paint, while the boat and the shadowed parts of the buildings are built up from an interplay of warm and cool points of color. The blue tones suggest the shadows; the warmer colors, the play of reflected sunlight and the colors of the materials out of which the objects are made.

Small though they are, these points of color remain clearly visible when the painting is viewed from a normal distance. Seurat did not intend them to fuse wholly in the viewer's eye but wanted the varied colors to vibrate against each other; in *The Lighthouse at Honfleur,* the touches of soft color in sky and sea are particularly successful in suggesting the shimmering haze of a summer day.

Even when working from a natural subject, Seurat organized his compositions with great care. Here all the darker forms are to the right, but the bold vertical of the lighthouse and the boat placed near the left margin allow the luminous, open left side to hold its own. He began this painting at Honfleur on the estuary of the Seine, but the protracted work of completing it must have been done in his Paris studio; from his initial natural subject he created a grand and monumental final image.

Colorplate 38.
The Lighthouse at
Honfleur. *1886.*
66.7 × 81.9 cm
(26¼ × 32¼ in.)
Collection of Mr. and
Mrs. Paul Mellon, 1983

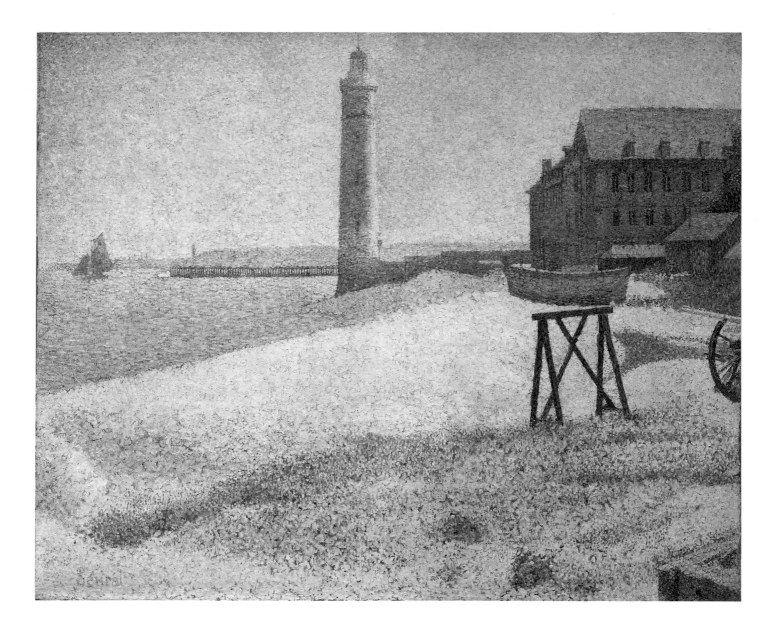

FARMHOUSE IN PROVENCE, ARLES
VINCENT van GOGH (1853–1890)

Van Gogh traveled south early in 1888 to Arles in Provence after two years in Paris that had transformed his painting. In place of the dark tones with which he had treated the peasant subjects he had favored in his native Holland, he absorbed the brilliant color and broken brushwork of impressionism. He went south in search of clearer light and brighter color and also to escape the pressures of Paris, seeking to digest what he had seen and heard there.

Farmhouse in Provence, Arles shows the impact of impressionist painting clearly in its color and brushwork; freely dabbed red flowers stand out from the firmly brushed yellow greens of the foreground field. But in many ways it is very different from paintings like Sisley's *Meadow* (Colorplate 34). The brushwork is broader and heavier, and each area has a distinct, dominant color distinguishing it from its surroundings instead of being part of a single play of variegated color nuances; many forms in the picture are crisply defined, and some of them are outlined: the houses, the figure, and the gateposts. The eye focuses on the individual ingredients of the scene rather than on its overall effect, as van Gogh sought to bring out their essential forms and colors.

Cézanne, in *Houses in Provence* (Colorplate 16) had also gone beyond impressionism in his concentration on the structure of the farm buildings of the south, but van Gogh presents his buildings not just as solid volumes but as the social focus of the scene, standing amid the fields with haystacks in the farmyard and a peasant figure in the foreground. Peasant life had been his prime subject in Holland, and he deliberately turned back to such themes at Arles, seeking what he felt to be the essential qualities of human life in contrast to the superficial fashions of the city. This image of the farm standing amid the fields and beside the fruits of the harvest constitutes a powerful expression of his search for these timeless values.

Colorplate 39.
Farmhouse in
Provence, Arles. *1888.*
46.1 × 60.9 cm
(18⅛ × 24 in.)
Ailsa Mellon Bruce
Collection, 1970

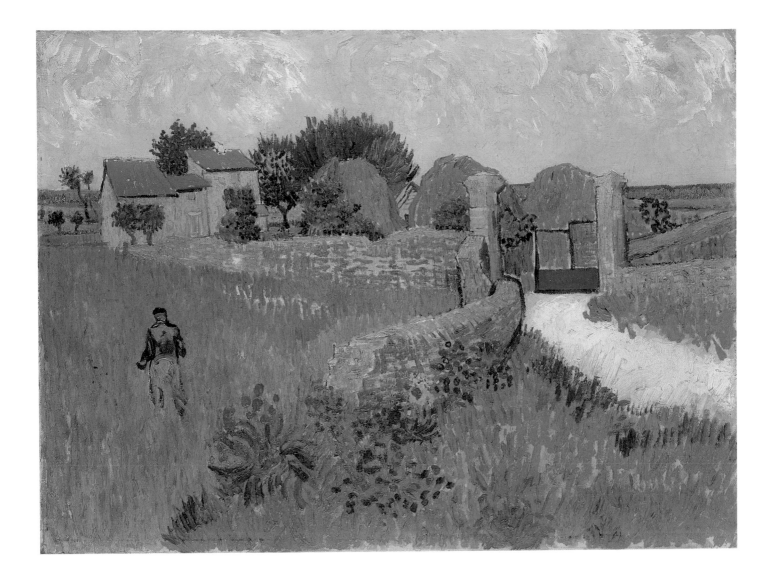

LA MOUSMÉ
VINCENT van GOGH

Landscapes formed the larger part of van Gogh's work after his move to France in 1886, but he wanted to be a figure painter above all, and he painted portraits and figure studies whenever a suitable model was available, as well as many self-portraits.

La Mousmé shows a young Provencal girl who sat for him at Arles in the summer of 1888. The title he gave the picture reflects his love for Japanese art—a *mousmé* is a young Japanese girl—but his feelings about Japan were not merely artistic. He had an idyllic vision of it as a country of clear sunlight where people lived in peaceful coexistence with nature and where the artist could work in harmony with the surroundings; he felt that in southern France, he was in the European equivalent of Japan. The idea of titling the picture *La Mousmé* came to him from a recently published popular novel about Japanese life, Pierre Loti's *Madame Chrysanthème*. This image of an innocent young girl holding a sprig of white flowers (van Gogh identified them as oleanders) is an expression of this idealized vision of Japan.

The handling of the picture, too, shows his interest in Japanese art in its limited range of clear color and its crisply silhouetted forms. But its thick paint layers and the variations of tone and touch in the flesh painting belong to the western oil-painting tradition. The clothes are built entirely from contrasts of blue against red and orange, and the bright red ribbon stands out very sharply against the light emerald green background. The bold red dots on the skirt give no sense of the folds in the material or the girl's form beneath it, but the treatment of the bodice and face gives her a strong sense of physical presence as her delicate form sits within the sweeping curves of the chair; her simple, frontal gaze enhances the picture's sense of immediacy.

Colorplate 40.
La Mousmé. *1888.*
73.3 × 60.3 cm
(28⅞ × 23¾ in.)
Chester Dale Collection, 1962

THE OLIVE ORCHARD
VINCENT van GOGH

The broken rhythmic brushwork covering the surface of *The Olive Orchard* still bears the imprint of van Gogh's experience of impressionist painting. However, the rhythms are far more unified than in Monet's *Woman Seated under the Willows* (Colorplate 11), for instance; the strokes here run throughout the sky, trees, and ground and vary little in scale, making scant concession to the variety of natural textures in the scene. The color is subdued and quite limited in range. When he painted the picture, van Gogh was in the hospital at Saint Rémy after the breakdown he had suffered at Arles at the end of 1888. At this period he painted the first versions of his landscapes outdoors but often executed further versions indoors; the very measured, even touch of *The Olive Orchard* suggests that it was one of the indoor canvases, in contrast to the more animated, variegated handling of those he painted outside.

The subject shows a scene van Gogh saw at Saint Rémy, but he intended his olive grove paintings to have a more generalized and symbolic meaning. He had heard of Gauguin's recent painting of *Christ in the Garden of Olives* (Norton Gallery and School of Art, West Palm Beach) and had strongly criticized its dependence on the painter's imagination rather than on observed nature. He intended his own pictures of olives as some sort of reply to this, seeking, as he wrote, to "give an expression of anguish without aiming at the historic garden of Gethsemane."

The Olive Orchard is primarily a scene of everyday life, showing the olive harvest. But something of the contrast between pain and solace is suggested by the simple, stable human figures grouped with their ladder into a pyramid, surrounded by the endlessly twisting rhythms of the trees; it is the natural forms that suggest further levels of meaning.

Colorplate 41.
The Olive Orchard.
1889.
73 × 92 cm
(28¾ × 36¼ in.)
Chester Dale Collection,
1962

BRETON GIRLS DANCING, PONT AVEN
PAUL GAUGUIN (1848–1903)

Gauguin had worked with Pissarro around 1880, but by 1888 he had come to reject the impressionists' preoccupation with transitory effects. Instead, he wanted his paintings to evoke what he saw as the essence of a scene, seeking the lines, rhythms, and colors that best expressed it. Reminiscences of Pissarro's brushwork can still be felt in the separate strokes that suggest the textures of foliage and hay in *Breton Girls Dancing* (see Colorplate 42), but these are quite subordinated to the crisply patterned design of the painting, which is dominated by the figures of the girls who stand out from their setting.

Gauguin painted *Breton Girls Dancing* at Pont Aven in southern Brittany. In a letter shortly before he painted it, he wrote: "I love Brittany; I find there the savage, the primitive. When my clogs ring out on this granite soil, I hear the dull, muted, powerful tone which I seek in my painting." It was by means of the simplified forms and cursive contours of figures like these that he sought to convey this quality in the slow-moving rhythms of the girls' dance. By placing them in front of an old cottage and the spire of the local church, he emphasized the apparent timelessness of the scene.

Paintings showing picturesque scenes in Brittany, enlivened by the local costumes and rituals of the inhabitants, were by the 1880s popular in art exhibitions in Paris. However, in Brittany the costumes, far from being an authentic survival of a primitive way of life, were being revived for the benefit of the burgeoning tourist industry, which the spread of railway travel had made possible (see Colorplates 7 and 26). Gauguin's vision of Brittany was essentially an expression of his dislike of the urban culture of Paris, which was later to lead him to leave France for the South Seas (see Colorplate 44). Both in Brittany and in Tahiti, the actual situation was very different from the images that he presented in his art, which showed the local people living in timeless harmony with their surroundings.

Colorplate 42.
Breton Girls Dancing,
Pont Aven. *1888.*
73 × 92.7 cm
(28¾ × 36½ in.)
Collection of Mr. and
Mrs. Paul Mellon, 1983

SELF-PORTRAIT
PAUL GAUGUIN

Gauguin painted this self-portrait on a wooden panel on a door in the dining room of the inn at Le Pouldu, a little coastal village near Pont Aven in southern Brittany where he and his friends stayed. The extreme flatness and simplification of its treatment relate directly to its original decorative purpose; none of Gauguin's easel paintings of this period were treated in this very schematic way.

Gauguin used self-portraiture on a number of levels both to create symbolic images of the creativity of the artist and to make more private comments, often ironic, about his personal dreams and fantasies. This picture operates on both levels. The halo suggests the role of the artist as he had described it the previous year: "to do as our divine master does, to create." Yet the presence of the apples, and of the snake in his hand, assigns him also the role of the tempter or the tempted. The divided background seems to complement this contrast. The red of the upper half evokes the spiritual plane of his experience (he had used red in this way the previous year in *Vision after the Sermon,* National Gallery of Scotland, Edinburgh), and the yellow zone below may suggest the physical realm—its shape is roughly that of his absent body. His face appears half in one plane, half in the other: his eyes, organs of vision, in the red, and his mouth, organ of bodily consumption, in the yellow.

But Gauguin did not intend his paintings to have a precise allegorical meaning. They should, he insisted, remain enigmatic and mysterious. The contrasts he set up in this self-portrait— between halo and snake, red and yellow—offer the viewer the freedom to explore the imagery and its resonances. The picture that began its life as a semicomic decoration in a country inn is also an exploration of the nature of art and its relationship to morality.

Colorplate 43.
Self-Portrait. 1889.
79.2 × 51.3 cm
(31¼ × 20¼ in.)
Chester Dale Collection,
1962

FATATA TE MITI
PAUL GAUGUIN

*F*atata te Miti was painted during Gauguin's first stay in Tahiti in 1891–93, and was exhibited in Paris on his return late in 1893. The inscription is in the Tahitian language, but in the 1893 exhibition catalogue Gauguin added a French translation, *Près de la mer* (By the sea) in order to make it comprehensible. On other occasions, he did not translate his Tahitian titles, using them instead to add to the exotic nature of his imagery.

Many of his Tahitian subjects, such as *Words of the Devil* (Figure 8), also painted in 1892, contain references to traditional Tahitian mythology. But *Fatata te Miti* does not; its subject is life by the seaside, with a man fishing in the background at the top and two women bathing below. However, the picture is in no sense a straightforward representation. The figures are cut off from the viewer by a huge tree trunk which partially hides the nakedness of the girl on the left. The immediate foreground cannot be read precisely; the curving pattern of lighter and darker mauve shapes and the plant forms playing across them are emphatically decorative and two-dimensional. The picture gives no sense of natural space or natural lighting; it is built up of sets of rhyming shapes that unite the foreground to the tree trunk and the waves.

The image Gauguin presented of Tahiti as an island paradise was largely fictitious. By the time he had reached the island, the process of westernization had gone so far that there were few remnants of traditional customs and culture. In his pictures, though, he combined many different elements: the facial features and patterned clothes of the natives, the evidence from the writings of earlier travelers, and his own sophisticated sense of design, which he had evolved in France from a study of Western and oriental art forms. Through this synthesis, he could evoke in his paintings an imagined idea of an Oceanic earthly paradise.

Colorplate 44.
Fatata te Miti (By the Sea). 1892.
67.9 × 91.5 cm
(26¾ × 36 in.)
Chester Dale Collection, 1962

CHILD WEARING A RED SCARF
ÉDOUARD VUILLARD (1868–1940)

In 1888–89 a group of young painters in Paris christened themselves the Nabis (Hebrew for prophets), under the inspiration of Gauguin's ideas (see Colorplates 43 and 44), which they had learned of through one of their number, Paul Sérusier. Their basic aim was stated in 1890 by another member of the group, Maurice Denis: "Remember that a picture—before being a war horse, a nude woman or some trivial anecdote—is essentially a flat surface covered with colors arranged in a certain order." From a twentieth-century viewpoint, this sounds like a prescription for nonrepresentational painting, but that was not Denis's intention. His point was that the art of painting should use its own means—forms and colors on a two-dimensional surface—to express its subjects rather than resorting to means extraneous to it, such as literary anecdote or illusionism that apes visual appearance. Subject matter was of great importance for the Nabi painters, with Sérusier and Denis favoring religious themes while Vuillard and Bonnard (see Colorplate 48) concentrated on scenes of everyday life.

Child Wearing a Red Scarf was painted when the links between the group were still very close. Much of its color is laid on very flatly, particularly the gray tones on the ground, as if to stress that the surface of the painting is flat, not receding into space; in many small areas, the brown surface of the board on which the picture was executed is left unpainted. The figure group revolves around the child with her lavishly speckled orange-red scarf and her red-dotted skirt; together with the blue bow in her hair, these give a sharply colored focus to a largely monochromatic painting. Beside her, the man whose hand she holds is cropped by the frame, his head and right arm invisible; all we see of him is what is within reach of the child. Wittily, Vuillard signed the painting on the back of the man's neck, just below the top of the picture, as if to associate himself with this adult presence. In this delightfully simple image, Vuillard recreated the child's viewpoint through the arrangement and framing of the figures and through the crisply defined contours that so clearly characterize their gestures.

Colorplate 45.
Child Wearing a Red
Scarf. circa 1891.
29.2 × 17.5 cm
(11½ × 6⅞ in.)
Ailsa Mellon Bruce
Collection, 1970

WOMAN IN A STRIPED DRESS
ÉDOUARD VUILLARD

From the early 1890s on, domestic interiors were Vuillard's favorite theme. He treated such subjects in numbers of small pictures and made them the theme for larger canvases designed as decorations for the houses of friends. In the mid-1890s these interiors were particularly densely packed by furniture and flowers and by the rich patterns of curtains, hangings, and wallpaper. They generally include figures who sometimes converse and sometimes sit preoccupied with their own activities, sewing or reading. However, the viewer is never informed about the relationships between them; they and their surroundings are treated as parts of a single domestic decor.

In *Woman in a Striped Dress,* the bold red and white stripes are balanced by the stems of the flowers on the right, and the heads of the flowers in the center form as sharp a visual focus as the faces of the women. The deep red of their dresses is echoed throughout, in the background and above the table top; this unites the whole surface more emphatically into a single decorative ensemble. Vuillard used very similar combinations of color and patterning in a contemporary set of decorative paintings for the house of Dr. Louis Henri Vaquez (Musée du Petit Palais, Paris).

Although the brushwork is mostly free and the forms mainly loosely defined, the structure of the picture is tightened by a few more sharply defined contours: the profile of the foreground figure, the vases, and the box with a dark blue lid at bottom right. Despite its apparently informal technique, the painting is very carefully composed. Vuillard worked out his pictorial arrangements in long sequences of preparatory drawings in order to translate his everyday themes into such resolved, closely knit paintings.

Colorplate 46.
Woman in a Striped
Dress. *1895.*
65.7 × 58.7 cm
(25⅞ × 23⅛ in.)
Collection of Mr. and
Mrs. Paul Mellon, 1983

A CORNER OF THE
MOULIN DE LA GALETTE
HENRI de TOULOUSE-LAUTREC
(1864–1901)

The cafés and night life of Paris were Toulouse-Lautrec's prime subject. He did not try to idealize this life; rather, he was always fascinated by the varied types who frequented the city's entertainments and sought to capture the essence of their expressions and gestures. He used two principal means to achieve this: his pictorial composition and his drawing. His compositions owe much to Degas in the unusual angles of view and in the avoidance of single, central focuses in his scenes; often he used the margin of the picture to cut off the figures, thus suggesting that the "slice of life" continues beyond the confines of the picture. His drawing, though, is quite unlike Degas's. Whereas Degas generalized the features of his figures (see Colorplate 29), Lautrec used a subtle process of emphasis and exaggeration to suggest character with great insight and veracity; his crisp drawing belongs to the traditions of the graphic arts and caricature.

In *A Corner of the Moulin de la Galette,* the crisp orange strokes on the cheek of the man on the right and the sharply drawn bags under his eyes are set alongside the incisive profile and pallid face of the woman in the foreground, who looks away from him; despite their physical proximity, there is no communication between them. The figures in the background are also separate from one another; we do not know where the standing woman in black is directing her gaze. Rarely do Lautrec's figures communicate readily with one another, and rarely did he depict good-looking faces or show figures in their best light. But he generally treated human imperfections—particularly in women—with sympathy rather than satire; the painter does not pass judgment on them from outside but seems to participate in their frailty and sense of isolation. In *A Corner of the Moulin de la Galette,* Toulouse-Lautrec created one of the most perceptive images of human privacy put on public display.

Colorplate 47.
A Corner of the
Moulin de la Galette.
1892.
100.3 × 89.1 cm
(39½ × 35⅛ in.)
Chester Dale Collection,
1962

TWO DOGS IN A DESERTED STREET
PIERRE BONNARD (1867–1947)

Bonnard, like his fellow Nabi, Vuillard (see Colorplates 45 and 46), focused his attention on informal, everyday scenes, particularly, in his early work of the 1890s, on Parisian streets and their life. The subject of *Two Dogs in a Deserted Street* is utterly trivial; the horizontal and vertical bands of street and houses are punctuated only by a wheelbarrow and the two dogs. But the dogs—so economically treated as mere shapes without shadows yet so wittily characterized—animate the open space, and the varied interplay of the windows enlivens the upper part of the picture.

The color is very restricted, with the soft pink of the road set against cool grays elsewhere, but the grays of the walls and windows are punctuated by a narrow brown door and by three little deep blue squares, presumably suggesting ventilation grills or something of the like. The whole surface, following the Nabis' principles (see Colorplate 45), is emphatically two-dimensional in effect, but through the arrangement of these restricted colors and simple forms, Bonnard has vividly suggested the effect of an open city street, while the dogs and the barrow, the closed doors and shuttered windows all evoke the invisible human presence.

Paintings like this are quite unlike the lavish color and free brushwork of the landscapes Bonnard painted after 1910, but like these later paintings, it reveals his remarkable control over the interrelations of color and pattern by which he could transform even the most casually grouped assemblage of forms into a richly coherent pictorial effect.

Colorplate 48.
Two Dogs in a
Deserted Street.
circa 1894.
35.1 × 27.0 cm
(13⅞ × 10⅝ in.)
Ailsa Mellon Bruce
Collection, 1970

TIME LINE

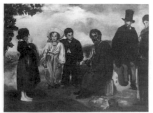

Manet—THE OLD
MUSICIAN, 1862

Boudin—JETTY AND
WHARF AT TROU-
VILLE, 1863

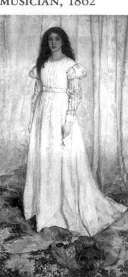

Whistler—THE WHITE
GIRL, 1862

Monet—BAZILLE AND
CAMILLE, 1865

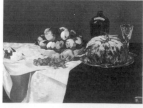

Manet—STILL LIFE
WITH MELON AND
PEACHES, c. 1866

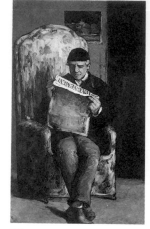

Cézanne—THE ART-
IST'S FATHER, 1866

1862	1863	1864	1865	1866
Hugo, LES MISÉRABLES	Manet, DÉJEUNER SUR L'HERBE; OLYMPIA	Verne, JOURNEY TO THE CENTER OF THE EARTH	Mallarmé, L'APRÈS-MIDI D'UN FAUNE	Degas begins to paint his ballet scenes
Sarah Bernhardt's debut (minor part) at Comédie-Française	Salon des Refusés in Paris opens	Berlioz, THE DAMNATION OF FAUST	Carroll, ALICE'S ADVENTURES IN WONDERLAND	Dostoevsky, CRIME AND PUNISHMENT
Köchel listing of Mozart's works published	Winged Victory of Samothrace discovered	Offenbach, LA BELLE HELENE	Taine, PHILOSOPHY OF ART (1865–69)	Offenbach, LA VIE PARISIENNE
Bismarck becomes Prime Minister of Prussia	French photographer Nadar makes ascent in his balloon, *Le Géant*	First International Workingmen's Association founded by Karl Marx (London, New York)	Wagner, TRISTAN AND ISOLDE	Venice unites with Italy
World's Fair opens (London)	Perrier introduced commercially	Pasteur invents pasteurization process for wine	Mendel enunciates his Law of Heredity	Transatlantic telegraph cable completed
First Monte Carlo gambling casino opens			Lister initiates antiseptic surgery	
Foucault successfully measures the speed of light				

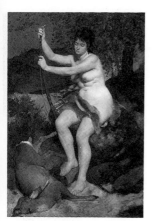

Renoir—DIANA, 1867

Morisot—THE HARBOR AT LORIENT, 1869

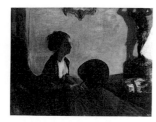

Degas—MADAME CAMUS, 1869–70

1867	1868	1869	1870	1871
Ingres retrospective World's Fair in Paris introduces Japanese art to the West	Discovery of cave paintings at Altamira	Flaubert, SENTIMENTAL EDUCATION	Louvre, begun in 1200, is completed	Darwin, DESCENT OF MAN
Zola, THERÈSE RAQUIN	Lautréamont, LES CHANTS DE MALDOROR (1868–70)	Verlaine, FÊTES GALANTES	Verne, TWENTY THOUSAND LEAGUES UNDER THE SEA	Verdi, AIDA
Burckhardt, RENAISSANCE PAINTING IN ITALY	Wagner, DIE MEISTERSINGER VON NÜRNBERG	Parliamentary monarchy established in France	Tchaikovsky, ROMEO AND JULIET	L'INTERNATIONALE, workers' anthem, composed by two French workers
Nobel patents his invention of dynamite	Strauss, TALES OF THE VIENNA WOODS	Samaritaine Department store opens in Paris	Franco-Prussian War; French defeat at Sedan; revolt in Paris and proclamation of the Third Republic; Prussians lay siege to Paris	The Commune in Paris rules for two months
	Revolution in Spain	First electric motor (Watt)	Mendeleyev formulates Periodic Table of Elements	Thiers elected President of France
	Disraeli becomes British Prime Minister; succeeded by Gladstone after general election the same year	Died: Berlioz, Lamartine, Saint-Beuve		French Empire officially abolished
	Skeleton of Cro-Magnon man found in France			France cedes Alsace-Lorraine to Germany and pays indemnity of 5 billion francs

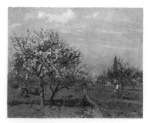

Pissarro—ORCHARD
IN BLOOM, LOUVE-
CIENNES, 1872

Degas—THE RACES,
c. 1873

Manet—BALL AT THE
OPERA, 1873

Sisley—MEADOW,
1875

Renoir—A GIRL WITH
A WATERING CAN,
1876

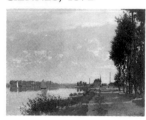

Monet—ARGENTEUIL,
c. 1872

Manet—GARE SAINT-
LAZARE, 1873

Cézanne—HOUSE OF
PÈRE LACROIX, 1873

Monet—WOMAN
WITH A PARASOL
MADAME MONET AND
HER SON, 1875

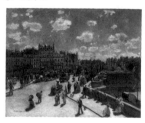

Renoir—PONT NEUF,
PARIS, 1872

1872	1873	1873–1874	1875	1876
Bizet, incidental music to L'ARLESIENNE	Rimbaud, A SEASON IN HELL	First Impressionist exhibition	Bizet, CARMEN Saint-Saëns, DANSE MACABRE	Second Impressionist exhibition
Verne, AROUND THE WORLD IN EIGHTY DAYS	Saint-Saëns, CONCERTO NO. 1 IN A MINOR FOR CELLO AND ORCHESTRA	Verdi, REQUIEM	Constitution voted in France, formally establishing parliamentary system	Bayreuth Festspielhaus opens with the first complete performance of Wagner's RING cycle
Civil War in Spain	Brahms, VARIATIONS ON A THEME BY HAYDN	Mussorgsky, BORIS GODUNOV	Milk chocolate invented	Alexander Graham Bell invents the telephone
Development of first plastic (Belgium)	DDT invented		Died: Corot, Millet	
	Color photographs first produced			

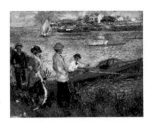

Cassatt—LITTLE GIRL
IN A BLUE ARMCHAIR,
c. 1875

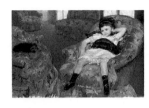

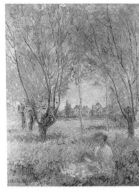

Renoir—OARSMEN AT
CHÂTOU, 1879

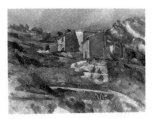

Cézanne—HOUSES IN
PROVENCE, c. 1880

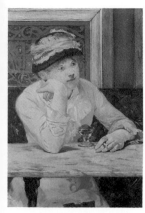

Manet—THE PLUM,
c. 1877

Monet—WOMAN
SEATED UNDER THE
WILLOWS, 1880

Tissot—HIDE AND
SEEK, c. 1877

Monet—BANKS OF
THE SEINE, VÉTHEUIL,
1880

1877	1878	1879	1880	1880
Third Impressionist exhibition	World's Fair in Paris exhibits Delacroix, Millet; excludes T. Rousseau	Fourth Impressionist exhibition	Fifth Impressionist exhibition	
Flaubert, THREE TALES		Pasteur formulates principle of vaccination	Rodin, THE THINKER	
Tolstoy, ANNA KARENINA	Whistler brings libel suit against Ruskin over Ruskin's attack on NOCTURNE IN BLACK AND GOLD: A FALLING ROCKET	Pavlov develops concept of conditioned reflex	Satie, THREE GYMNOPÉDIES	
Saint-Saëns, SAMSON AND DELILAH			France annexes Tahiti	
Tchaikovsky, SWAN LAKE		Died: Daumier	Died: Flaubert, Offenbach, Eliot	
Died: Courbet, Thiers	James, THE EUROPEANS			
	L.C. Tiffany establishes his stained glass factory in New York			

Pissarro—PEASANT GIRL WITH A STRAW HAT, 1881

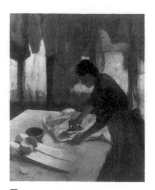

Degas—WOMAN IRONING, 1882

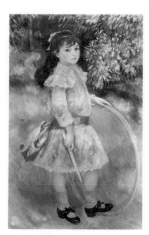

Renoir—GIRL WITH A HOOP, 1885

Seurat—THE LIGHT-HOUSE AT HONFLEUR, 1886

1881	1882	1883–1884	1885	1886–1887
Sixth Impressionist exhibition	Seventh Impressionist exhibition	Impressionist shows in London, Berlin, and Rotterdam	France, Britain, Germany and Belgium establish control over wide-ranging areas of Africa	Eighth and last Impressionist exhibition
The first cabaret, Le Chat Noir, opens in Paris	Musée des Arts Décoratifs established	Nietzsche, THUS SPAKE ZARATHUSTRA	Pasteur devises rabies vaccine	Impressionist show organized in New York by Durand-Ruel
Freedom of press and of assembly and free compulsory education established in France	Wagner, PARSIFAL	Orient Express makes its first run from Paris to Constantinople	Eastman manufactures coated photographic paper	Bonaparte and Orléans families banished from France
St. Gotthard railroad tunnel through the Alps completed	Economic depression in France	Died: Manet, Doré, Marx, Wagner, Turgenev		First exhibition of posters (Paris)
Grand boulevards in Paris lit by electricity		Manet retrospective		First exhibition devoted exclusively to the Japanese print (Paris)
		Huysmans, AGAINST NATURE		Paris premiere of Wagner's LOHENGRIN
		Strikes by workers legalized in France		
		First issue of LE MATIN		

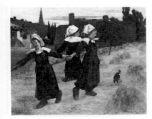

Gauguin—BRETON GIRLS DANCING PONT AVEN, 1888

van Gogh—FARM-HOUSE IN PROVENCE, ARLES, 1888

van Gogh—LA MOUSME, 1888

van Gogh—THE OLIVE ORCHARD, 1889

Gauguin—SELF-POR-TRAIT, 1889

Vuillard—CHILD WEARING A RED SCARF, c. 1891

Toulouse-Lautrec—A CORNER OF THE MOULIN DE LA GA-LETTE, 1892

Gauguin—FATATA TE MITI (BY THE SEA), 1892

Renoir—BATHER AR-RANGING HER HAIR, 1893

1888	1889–1890	1891	1892	1893
Rimsky-Korsakov, SCHEHERAZADE	Monet organized a subscription to purchase Manet's OLYMPIA for the Louvre	Van Gogh exhibition at Salon des Independents	Post-impressionist exhibition (including Pissarro, Seurat, Signac)	Munch, THE SCREAM
Construction begins on Eiffel Tower for World's Fair	First May Day celebration (Paris)	Gauguin settles in Tahiti	Leoncavallo, I PAGLIACCI	Art Nouveau movement emerges in Europe
Michelin Brothers begin to manufacture bicycle tires	French Panama Canal bankrupt	Toulouse-Lautrec produces his first music-hall posters		Chicago World's Fair exhibits works by Degas, Manet, Monet, Renoir, and Pissarro
	France gives up Nigeria to Britain; receives Algeria in return	Beginning of wireless telegraphy (France)		Bon Marché in Paris becomes the world's largest department store
	Bismarck forced to resign as Prime Minister by Kaiser Wilhelm	Died: Seurat, Jongkind, Meissonier, Rimbaud		
	Died: van Gogh			

125

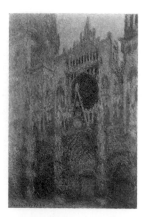

Monet—ROUEN CA-
THEDRAL, WEST FA-
CADE, 1894

Cassatt—THE BOAT-
ING PARTY, 1893–94

Cézanne—STILL LIFE
WITH PEPPERMINT
BOTTLE, c. 1894

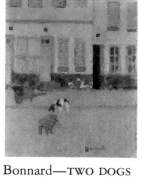

Bonnard—TWO DOGS
IN A DESERTED
STREET, c. 1894

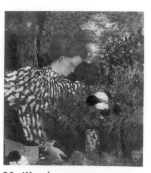

Vuillard—WOMAN IN
A STRIPED DRESS,
1895

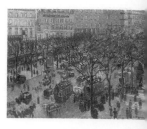

Pissarro—BOULE-
VARD DES ITALIENS,
MORNING, SUNLIGHT,
1897

1894	1894	1895	1896	1897–1898
Caillebotte leaves his collection of impressionist paintings to France Berenson, VENETIAN PAINTERS OF THE RENAISSANCE Lumiére invents the cinematograph		Vollard holds first one-man show of Cézanne's paintings Faure becomes president of French Republic First public film show in Paris Roentgen discovers X-rays Gillette invents safety razor Marconi invents radio telegraphy	Chekhov, THE SEA GULL New evidence for Dreyfus' innocence suppressed Becquerel discovers radioactivity First modern Olympics held in Athens	Rostand, CYRANO DE BERGERAC Gide, FRUITS OF THE EARTH Wells, THE INVISIBLE MAN First photographs by Atget Zola publishes J'AC-CUSE after Major Esterhazy is acquitted in Dreyfus case The Paris Métro opens Marie and Pierre Curie discover radium

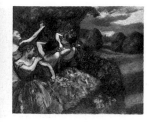

Degas—FOUR
DANCERS, c. 1899

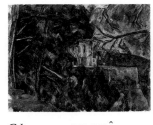

Cézanne—LE CHÂ-
TEAU NOIR, 1900–04

Cézanne—THE
SAILOR, c. 1905

1899	1900–1901	1902–1903	1904	1905
Joplin, MAPLE LEAF RAG	Freud, THE INTER-PRETATION OF DREAMS	Debussy, PELLÉAS AND MELISANDE	Matisse has first one-man show at Vollard's gallery	"Les Fauves" chris-tened by Vauxcelles
Dreyfus case retried; Dreyfus pardoned by presidential decree	Paris World's Fair	Caruso makes his first phonograph recording	Church and State sepa-rated by law in France	Einstein formulates Special Theory of Rel-ativity
First magnetic record-ing of sound	Discovery of Minoan culture in Crete	Meliès film, JOURNEY TO THE MOON	French government es-tablishes 10-hour work day	First automobile taxi-cabs introduced in Paris
Died: Sisley	Beginning of Picasso's Blue Period (to 1904)	Died: Zola, Tissot	Died: Fantin-Latour, Gérôme	Died: Bouguereau, Verne
	Ravel, JEUX D'EAU	Salon d'Automne founded		
	Marconi transmits transatlantic tele-graphic radio messages	Wright brothers' first successful flight		
	Died: Toulouse-Lau-trec	Died: Pissarro, Gau-guin, Whistler		

INDEX

KEY: Numbers in *bold* denote *Figures*. Those preceded by *c* denote *Colorplates*.

Advice to a Young Artist (Daumier), 15, 17, 23, *14*
Andrew W. Mellon (Birley), 14–15, *12*
Argenteuil (Monet), 40–42, 46, 52, 78, 84, *c9*
Artist's Father, The (Cézanne), 22–23, 50–51, 60, *20*, *c14*
Balcony, The (Manet), 74
Ball at the Opera (Manet), 23, 28, 30–31, *20*, *c4*
Banks of the Seine, *Vétheuil* (Monet), 42, 44, 46–48, 68, *c12*
Bather Arranging Her Hair (Renoir), 62, 72–73, *c25*
Battle of Love, The (Cézanne), 19–20, *16*
Baudelaire, Charles, 36
Bazille, Frédéric, 10, 22–23, 38
Bazille and Camille (Monet), 20, 23, 36, 38–39, 42, *20*, *c8*
Boating (Manet), 96
Boating Party, The (Cassatt), 96–97, *c37*
Bon Bock, Le (Manet), 28
Bonnard, Pierre, 20, 112, 118–119
Boudin, Eugène, 10, 36–37, 74, 106
Boulevard des Italiens, *Morning*, *Sunlight* (Pissarro), 88–89, *c33*
Breton Girls Dancing, *Pont Aven* (Gauguin), 106–107, *c42*
By the Sea (Gauguin), 20, 110
Cassatt, Mary, 10–11, 13, 94–97
Cézanne, Paul, 11, 17, 19–20, 22–23, 50–61, 70, 84, 86, 100
Chardin, Jean-Baptiste Siméon, 26
Château Noir, Le (Cézanne), 17, 58–59, *c18*
Chester Dale (Bellows), 18, *15*
Child Wearing a Red Scarf (Vuillard), 20, 112–113, 118, *c45*
Christ in the Garden of Olives (Gauguin), 104
Coast near Antibes (Cross), 20–21, *17*
Corner of the Moulin de la Galette, (Toulouse-Lautrec), 116–117, *c47*
Corot, Jean Baptiste Camille, 15, 74
Courbet, Gustave, 8–9, 17, 50, 62
Cross, Henri Edmond, 20–21
Dancer, The (Renoir), 10–11, 17, *6*
Daumier, Honoré, 15, 17, 23
Dead Toreador, The (Manet), 8, 14–15, 17, *3*
Degas, Edgar, 11–13, 17, 40, 76–83, 92, 94, 116
Déjeuner sur l'herbe (Manet), 24, 38
Delacroix, Eugène, 7, 9
Denis, Maurice, 112
Diana (Renoir), 50, 62–63, *c20*
Farmhouse in Provence, *Arles* (van Gogh), 20, 100–101, *c39*
Fatata te Miti (Gauguin), 20, 106, 110–112, *c44*
Four Dancers (Degas), 78, 80, 82–83, *c30*
Fragonard, Jean Honoré, 72
Gare Saint-Lazare (Manet), 17, 23, 28–30, 74, 94, *20*, *c3*
Gauguin, Paul, 10–11, 13, 20, 104, 106–112
Girl Arranging Her Hair (Cassatt), 10–11, *7*
Girl with a Hoop (Renoir), 66, 70–72, *c24*
Girl with a Watering Can, (Renoir), 17–18, 66–68, 70, 86, *c22*
Harbor at Lorient, The (Morisot), 18, 20, 74–75, 106, *c26*
Hide and Seek (Tissot), 92–94, *c35*
House of Père Lacroix (Cézanne), 52–53, 84, *c15*
Houses in Provence (Cézanne), 52, 54–55, 70, 86, 100, *c16*
Impression: Sunrise (Monet), 11
Incident in a Bullfight (Manet), 7–8
Jetty and Wharf at Trouville (Boudin), 36–37, 74, 106, *c7*
Kandinsky, Wassily, 13
King Charles Spaniel, (Manet), 9, *5*
Lighthouse at Honfleur, The (Seurat), 98–99, *c38*
Little Girl in a Blue Armchair (Cassatt), 94–96, *c36*
Luncheon of the Boating Party, The (Renoir), 68

Madame Camus (Degas), 76–77, *c27*
Madame René de Gas (Degas), 12–13, *9*
Manet, Édouard, 7–9, 12, 14–15, 17, 18, 23–34, 38, 50, 74, 92, 94, 96
Matisse, Henri, 13
Meadow (Sisley), 90–91, 100, *c34*
Monet, Claude, 10–11, 13–14, 18, 20, 23, 36, 38–49, 52, 68, 78, 84, 98, 104
Morisot, Berthe, 6–7, 18, 20, 74–75, 106
Morning Haze (Monet), 13–14, 18, *11*
Mother and Sister of the Artist, The (Morisot), 6–7, 18, *1*
Mousmé, La (van Gogh), 102–103, *c40*
Nabis, 112, 118
Negro Girl with Peonies (Bazille), 22–23, *19*
Oarsmen at Châtou (Renoir), 68–69, *c23*
Odalisque (Renoir), 7, 62, *2*
Old Musician, The (Manet), 9, 17, 24–26, 34, *c1*
Olive Orchard, The (van Gogh), 104–105, *c41*
Olympia (Manet), 50
Orchard in Bloom, *Louveciennes* (Pissarro), 52, 84–86, 90, *c31*
Parau na te Varuaïno (Gauguin), 10–11, 13, 20, 110, *8*
Peasant Girl with a Straw Hat (Pissarro), 54, 86–88, *c32*
Picasso, Pablo, 13
Pissarro, Camille, 11, 52, 54, 84–90, 106
Plum, The (Manet), 32–33, *c5*
Pont Neuf, *Paris* (Renoir), 20, 64–66, 70, *c21*
Poussin, Nicolas, 58
Races, The (Degas), 17, 40, 78–79, *c28*
Railroad, The (Manet), 28
Renoir, Auguste, 7, 10–11, 17–18, 20, 50, 62–73, 84, 86
Rouen Cathedral (Monet), 46, 48–49, *c13*
Rubens, Peter Paul, 58, 72
Sailor, The (Cézanne), 17, 60–61, *c19*
Salons des Refusés, 8–9, 17
Sargent, John Singer, 14
Self-Portrait (Gauguin), 108–109, 112, *c43*
Seurat, Georges, 11, 21, 98–99
Sisley, Alfred, 10, 90–91, 100
Still Life with Melon and Peaches (Manet), 9, 17, 23, 26–27, *20*, *c2*
Still Life with Peppermint Bottle (Cézanne), 56–57, *c17*
Stream, The (Courbet), 8–9, 17, *4*
Swing, The (Renoir), 66
Symphony in White No. 1 (Whistler), 34
Tissot, James, 92–94
Toulouse-Lautrec, Henri de, 116–117
Tragic Actor, The (Manet), 12, 14, *10*
Turner, J. M. W., 15
Two Dogs in a Deserted Street (Bonnard), 20, 112, 118–119, *c48*
Van Gogh, Vincent, 11, 20, 100–105
Velásquez, Diego, 24, 34, 66
Vision after the Sermon (Gauguin), 108
Vuillard, Édouard, 20, 112–115, 118
Wapping on Thames (Whistler), 21–22, 34, *18*
Whistler, James McNeill, 9, 11, 14, 15, 17, 21–22, 34–35
White Girl, The (Whistler), 9, 15, 17, 22, 34–35, *c6*
Woman Ironing (Degas), 80–81, 116, *c29*
Woman with a Parasol—Madame Monet and Her Son (Monet), 40, 42–43, *c10*
Woman with a Parrot (Courbet), 62
Woman Seated under the Willows (Monet), 44–46, 104, *c11*
Woman in a Striped Dress (Vuillard), 114–115, 118, *c46*
Words of the Devil (Gauguin), 10–11, 13, 20, 110, *8*
Zola, Émile, 50